A Life in Antebellum Charlotte

Sacrament of the L...

... I can not describe

... pathetic eloquence

... the assembled ...

... to be reconciled to G...

... God to us in Christ

... melted — I long...

... and confessed my

... of Jesus. —

... was firm and dec...

A Life in Antebellum Charlotte

The Private Journal of Sarah F. Davidson, 1837

Karen M. McConnell, Janet S. Dyer and Ann Williams, Editors

Published by The History Press
18 Percy Street
Charleston, SC 29403
866.223.5778
www.historypress.net

Copyright © 2005 by Karen M. McConnell, Janet S. Dyer and Ann Williams
All rights reserved

Cover image: Historic Rosedale. A painting by Chase Saunders.

First published 2005

Manufactured in the United Kingdom

ISBN 1.59629.088.9

Library of Congress Cataloging-in-Publication Data

Davidson, Sarah F. (Sarah Frew), 1804-1889.
 A life in antebellum Charlotte : the private journal of Sarah F. Davidson, 1837 / edited by Janet S. Dyer, Karen M. McConnell and Ann Williams.
 p. cm.
 Includes bibliographical references and index.
 ISBN 1-59629-088-9 (alk. paper)
 1. Davidson, Sarah F. (Sarah Frew), 1804-1889--Diaries. 2. Women--North Carolina--Charlotte--Diaries. 3. Charlotte (N.C.)--History--19th century. 4. Charlotte (N.C.)--Social life and customs--19th century. 5. Charlotte (N.C.)--Biography. I. Dyer, Janet S. II. McConnell, Karen M. III. Williams, Ann. IV. Title.
 F264.C4D385 2005
 975.6'7603--dc22
 2005023095

Notice: The information in this book is true and complete to the best of our knowledge. It is offered without guarantee on the part of the author or The History Press. The author and The History Press disclaim all liability in connection with the use of this book.

All rights reserved. No part of this book may be reproduced or transmitted in any form whatsoever without prior written permission from the publisher except in the case of brief quotations embodied in critical articles and reviews.

Contents

Foreword by Mary Kratt	7
Acknowledgements	9
Introduction	11
Maps	15
The Davidson family	19
About the journal	25
The Private Journal of Sarah F. Davidson, 1837	29
Epilogue	127
Biographical sketches	129
Susan Nye Hutchison	129
John J. Blackwood	130
The Reverend Abner Johnson Leavenworth	131
Catherine Wilson and William Julius Alexander	132
William W. and Mary A. Davidson Elms	134
Mary McComb and family	135
Slaves of William Davidson	136
The Sabbath school movement	137
Early Holy Communion practices	141
Gold mining and the Charlotte Mint	143
A short history of Rosedale	147
Selected bibliography	149
Index	151
About the editors	155

Foreword

Sarah Frew Davidson did not intend for anyone to read her journal, not even her teacher and mentor, Susan Nye Hutchison.

But we are, and here it is, wonderfully revealed as the account of one year of her life, 1837, in Charlotte, North Carolina. We see her as she travels, sometimes on horseback or by carriage, or walking the muddy road in overshoes between the center of the rustic village of Charlotte and her family's plantation, The Grove, three miles northwest of town.

Sarah is single, thirty-three and of the gentry class. Her father had served as a state senator, then a United States congressman and she is doing what fashionable young women did; recording her life of visiting, teaching piano, practicing domestic crafts, chafing against the strictures of women's fashions and social calls, nursing the sick, supervising servants, tending her widowed father's household with about eighty slaves and teaching some of these slaves to read despite its being against the law. Dominating her life is a preoccupation with her recent spiritual awakening, which coincided with the sweeping American religious era of the Great Revival in the early 1800s. Sarah is an honest woman, expressing to her journal what she might not to her peers, how her fervor is pocked with serious self-doubt.

Her journal is a rare, fine-focused glimpse of life in antebellum Charlotte including: a blind horse found in the bottom of a mine shaft, the remarkable appearance of the aurora borealis, the rise of the Sabbath school movement (in which Sarah teaches) and her father's encroaching

A Life in Antebellum Charlotte

financial worries. She notes the outside visitors and cultural influences brought to town by the presence of the new U.S. Mint. We see a clearly feminine view of piety and social concerns in the time of Charlotte's rising prosperity due to local gold discovery and mining. In her spidery, elegant penmanship, she continually writes her religious concerns which include an unveiled snobbery toward Baptist preachers and her disapproval of frivolity. Even so, she obviously was a lively conversationalist, had many visitors and enjoyed long parlour conversations with male friends and ladies of her class.

The excellent annotations, which the diligent and thoughtful editors have inserted within the year-long journal, give a meticulous and extremely useful context for Sarah's report. They show the social history of Charlotte focusing on the 1830s and include important historical connections with the existing historic landmark plantation house of Rosedale and the careers of Robert Hall Morrison, first president of Davidson College, and Susan Nye Hutchison, the extraordinary diarist who taught in female academies in Raleigh, Salisbury and Charlotte.

History, particularly women's history in early nineteenth-century Carolina Piedmont, is often a puzzle, but here in her own words is Sarah's valuable key piece of the whole. Her journal with its documented context, so capably presented here, is a gift to Charlotte and to a wider understanding of women's history in the antebellum South.

<div style="text-align:right">

Mary Kratt
Charlotte, North Carolina
2005

</div>

Acknowledgements

In the late 1990s a photocopy of Sarah Frew Davidson's handwritten journal was received by Historic Rosedale, the nineteenth-century plantation home of Sarah's sister Harriet. The journal had been handed down in the family, lastly to Harriet's great-great granddaughters, Mary Louise Davidson (now deceased) and Alice Davidson Abel. Alice generously donated the journal to the Rare Books and Manuscript Collection at the University of North Carolina at Charlotte. We are deeply indebted to these two women for preserving the journal and for their keen lifelong devotion to history.

With great enthusiasm a group of Rosedale's staff and volunteers set about transcribing the journal. We congregated pleasurably on the back porch of the old plantation house for a delightful spring and summer. With pages of the journal spread out before us, we launched forth on a heady adventure. Ours was no simple task. The overall appearance of Sarah's beautiful script was schoolgirl perfect, yet her handwriting was cramped and tiny, and many words seemed determined to elude us.

Week by week we gathered, each person transcribing a few pages, then swapping them about for a pair of fresh eyes to pick up errors and fill in the blanks. We shared excitement when words and phrases fell into place, and marveled at the little incidents of Sarah's life, all the while searching for Harriet, whose cool and breezy porch we occupied. We owe a tremendous debt to that joyful group of volunteer transcribers, too loosely bound to be called a committee. They consisted of a dozen or

A Life in Antebellum Charlotte

so docents, some serving Historic Rosedale, and a broader group from the Mecklenburg Historical Association. Many wore both hats. Some worked consistently, others occasionally. We will not attempt to name them, for fear of omissions. They are all deeply appreciated.

Then the editors got down to work. As the transcription was checked and rechecked, it became apparent that Sarah's journal was not telling us the story we sought, but one of broader significance. We had hoped to shed light on Harriet, helping us interpret Rosedale as a historic site, yet Sarah barely mentioned her sister. Instead she gave us a portrait of Charlotte in 1837, a pivotal year for the gold-mining village, and details of society and plantation life. We were familiar with the broad facts of our history, but Sarah's journal coaxed us to look deeper and see their influence on ordinary lives. We researched and wrote with abandon.

We again asked volunteers to read Sarah's journal, now enhanced by an introduction, annotations and biographical details. Their comments were invaluable. Thank you so very much; you know who you are. Several people deserve special mention: Chase Saunders painted the lovely portrait seen on the cover of Historic Rosedale, now restored to its nineteenth-century appearance; Janet Dyer, in addition to her editorial responsibilities, created the maps, showcasing her splendid artwork; and Jane Estep was our excellent photographer.

Thanks also to the staff at Historic Rosedale for valuable assistance and encouragement; a portion of the profits from the sale of this book will benefit this wonderful old plantation, upholding its mission in keeping our history alive. We greatly appreciate the Mecklenburg Historical Association for their support, enthusiasm and generosity, not only for this project, but for all they do in our community. We are especially indebted to Robin Brabham and his staff at the J. Murrey Atkins Library of the University of North Carolina at Charlotte, where Sarah's journal resides. We hope her antebellum story will be as interesting and instructive to others as it was to us.

Introduction

Sarah Frew Davidson began her journal in January of 1837. She was an unmarried lady of thirty-three years and lived with her widowed father on his Mecklenburg County plantation called The Grove, some three miles northwest of Charlotte, North Carolina. Charlotte was a village then, about a square mile in size, and home to about eight hundred inhabitants. According to the tax list of 1840, Charlotte had twelve stores, one bank agent, three taverns, one tannery, one printing office, one weekly newspaper, two academies, one common school, two ministers, six lawyers and six doctors. Personal property lists included thirteen pleasure carriages, eighty-three gold watches, thirty-eight silver watches and twenty-four pianos. Although most of Mecklenburg's people were rural farmers scattered around the countryside, Sarah's closest friends lived within the bounds of the village.

Gold mining was the principle business of the town. In 1799, gold had been discovered in neighboring Cabarrus County. By the 1830s there were a number of gold mines in Mecklenburg and the surrounding counties. The economic depression of 1837 had severe effects on most of the nation, but the Carolina Piedmont prospered because of its gold. That same year a branch of the U.S. Mint was opened in Charlotte to assay ore and mint coins. Mining and the mint flourished until far richer lodes were discovered and developed in California. Most of the male figures encountered in Sarah's journal were involved in the mint or the mining industry as engineers, supervisors and also as investors. It is interesting

to note that Sarah mentioned this business casually, as if living in such a heady sphere was perfectly ordinary.

As a young girl Sarah attended the Raleigh Academy, a female boarding school. Her most influential teacher there was Mrs. Susan Nye Hutchison. By 1837 Mrs. Hutchison had been hired by the Salisbury Female Academy about forty miles from Charlotte. She renewed her friendship with several of her former pupils in the Charlotte area, and it was at the urging of Mrs. Hutchison that Sarah began her journal. Its purpose was self-examination and reflection as well as keeping a record of daily life.

A religious revival swept the South in the early 1800s, and many upper-class women experienced spiritual rebirth. The journal served Sarah Davidson as a tool in her personal journey as a typical evangelical Christian lady of her time and class, and served to record her move toward the church and spiritual pursuits. Early in her journal Sarah expressively recalled her "awakening" to Christ's call, and acknowledged the Reverend Robert Hall Morrison, a Presbyterian minister, as the instrument of that awakening. As an evangelical Christian woman she regarded faith as a deep personal commitment requiring a thorough scrutiny of thoughts and emotions. Examination of feelings, desires and motives was encouraged by the church, which deemed man unworthy and subject to salvation only through the grace of God. Her rich spiritual journey, so eloquently explored through her writings, is representative of many wealthy southern women of her time.

The revival was less successful with male members of antebellum society. Many clung to an interpretation of religion focused on reason and avoided the more emotional aspects of the evangelical church. Sarah, while always the submissive daughter, piously tried to win her father and brother away from popular vices and zealously endeavored to convert her "lost" family and friends in order to save them from an eternity of damnation.

During the year of her journal, Sarah worshiped at the Presbyterian Church in the village. Reverend Morrison was its minister 1827–1833. It was probably in 1833 when a highly successful revival was held at the church that she experienced the rebirth described early in her journal. By 1837 when Reverend Morrison took the position of president of the newly opened Davidson College, the young Reverend Abner Leavenworth had occupied the pulpit for several years. He garnered much praise and admiration from the devout Sarah. The church building,

which stood where First Presbyterian Church stands today, had been constructed by the community for the use of many denominations during Charlotte's early years. The Presbyterian congregation, the largest and the only one with a full time minister, purchased the building in 1832. Several other denominations continued to use the church for worship services. Sarah attended services of all sects held at the church and some elsewhere in the village, but her opinion of the ministers varied greatly. Later when the Episcopalians built their own sanctuary, she became a member of that congregation.

As a member of the gentry class, Sarah Davidson demonstrated her place in society through her dress, manner of conversation and her physical bearing. In positions of wealth and leisure, slave-holding women of the old South had much time for social occasions and frivolous activities. The church, however, urged their female members to spend their time in more righteous pursuits. Religious writers of the time condemned popular pastimes such as balls, parties and socializing as wasteful and distracting, and encouraged women to tend to domestic duties and spiritual pursuits such as Sunday schools and benevolent societies. Although Sarah greatly enjoyed social occasions, especially with friends and family, she often chastised herself for deriving pleasure from these frivolous encounters. Soon after her spiritual awakening, she and a few of her friends committed to reestablish a Sabbath school in the village of Charlotte. The school not only taught religious principles, but endeavored to provide reading and writing to children of the community's poorer citizens. Sarah also joined the Benevolent Society. These activities helped assuage her guilt and provided her with an acceptable means of socializing with her friends.

Sarah's father, the former Senator William Davidson, owned a plantation called The Grove. It was one of Mecklenburg's largest plantations, and was located off Beatties Ford Road in the present day Hoskins community. The senator raised cotton, operated a gold mine and raised food crops to support his family and slaves. It was The Grove that Sarah called home. The three miles to town was no obstacle for Sarah as she traveled to the village several times a week and always on Sunday. She often rode horseback, which she greatly enjoyed, or walked or traveled in a carriage on these frequent trips. Her sister Margaret and brother-in-law James H. Blake lived in a Davidson family home on the southwest corner of the village square, directly across from the Court House. Sarah resided with them while in the village. Today Thomas Polk Park occupies the site of their former home.

A Life in Antebellum Charlotte

Sarah served her widowed father as mistress of The Grove supervising and instructing his slaves as well as providing for their needs. Her commitment to bringing others to Christ extended to the slaves, which in 1837 numbered around eighty. Sarah felt that reading the Bible was instrumental in directing the spiritual lives of "her people." Her journal recorded her struggle between obedience to God and the law that forbade teaching slaves to read. It was a relatively new law having been enacted in North Carolina in 1831. She concluded that her higher allegiance was to God, and with her father's consent began classes for her young slaves to teach them to read the Bible and instruct them in its meaning. In February she remarked that six weeks before she had commenced teaching the young servants to read. There were probably about twenty-five slave children on the property; she listed the names and accomplishments of sixteen of them.

Her management of the adult slaves is sometimes subtly noted. She often wrote that she *had* work done, not that she had done it herself. On other occasions she was more explicit when a task was not performed to her liking. She expressed a great deal of compassion for sick or dying slaves, yet no remorse about owning them, typical of her time and class. She accepted matter-of-factly that slaves were biblically ordained inferiors, and it was her responsibility to care and provide for them to the best of her ability. Often she was the only white female on the plantation, a situation that sorely tested her obligation.

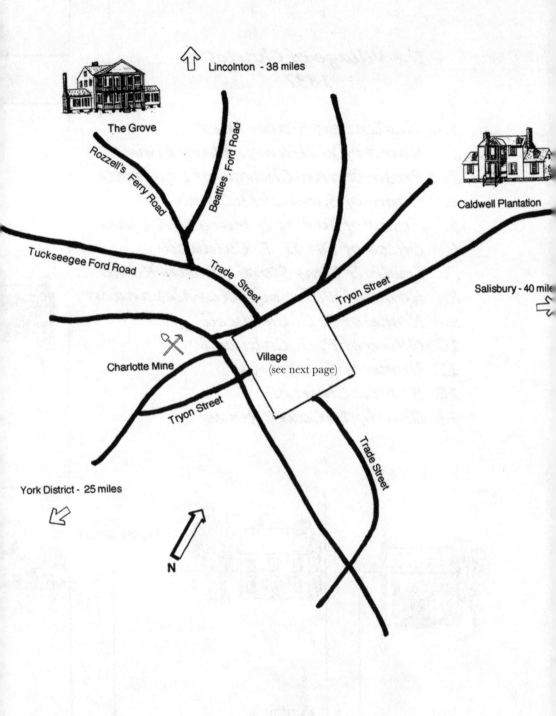

The Village of Charlotte
1837

1. The United States Mint
2. Home of William & Mary Elms
3. Presbyterian Church of Charlotte
4. Home of Samuel McComb
5. Home of James & Margaret Blake
6. Office of Dr. D. T. Caldwell
7. Irwin & Elms Store - Irwin Home
8. Home of William Julius Alexander
9. Home of P. C. Caldwell
10. Office of P. C. Caldwell
11. Home of Eli Springs
12. Baptist Church
13. Charlotte Court House

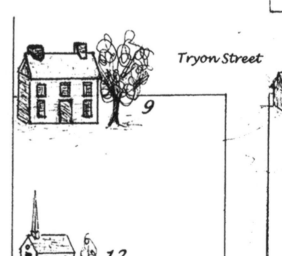

Tryon Street

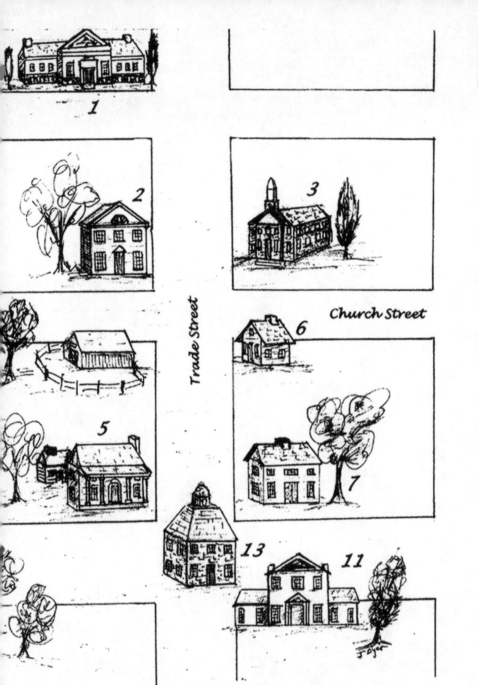

Locations of houses were derived from the historic record. The drawing is the artist representation.

The Davidson family

Sarah Frew Davidson was born in 1804 in the village of Charlotte, the daughter of William and Sarah Frew Davidson. William was one of the wealthiest men in Mecklenburg County as Sarah was growing up. He began his political appointments as Keeper of the Weights and Measures of Mecklenburg County in 1804, and over the years held positions as Postmaster and Justice of the Peace. A branch of the Bank of New Bern was located in a house which belonged to the family on the square in the village. William Davidson served as cashier until 1832 when the bank was closed. He was elected to represent Mecklenburg County in the North Carolina Senate from 1813 until 1818 when he was elected to the U.S. Congress (where he served until 1821). Several years later he was again elected to the North Carolina Senate, and served from 1825 until 1830. For the rest of his life he was always called Senator Davidson.

Sarah's mother, after whom she was named, died the year Sarah turned eight years old, and the journal never mentions her. Sarah's siblings were Margaret A. Davidson, born in 1803, just one year before Sarah; Harriet Elizabeth Davidson, born in 1806; and their brother William Archibald Frew Davidson, who was born about 1809.

In 1813, as their father prepared to leave for Raleigh to take his place in the senate, he began to consider the girls' schooling. Cherry, a slave who was the children's nursemaid, had seen to their welfare after their mother's untimely death. But Margaret, Sarah and Harriet

were old enough for boarding school. Many local families were sending their privileged daughters to the Salem Female Academy operated by the Moravian Church. It was an excellent school for young ladies of class and distinction. Sarah was only ten years old, but the academy in Salem, North Carolina agreed to take the young girls whose mother was dead.

In 1814 the girls were enrolled. All three of them received a liberal education in the higher branches of study including needlework and music. Sarah was among the youngest at the school, but seemed to do well. The Davidson girls were moved to the Raleigh Academy in 1816 to be closer to their father while he served in the state capitol. Here they met Susan Nye Hutchison, an instructor. The young ladies formed a life-long friendship with the woman they called their "Preceptress." Mrs. Hutchison had a profound effect upon Sarah. She became her mentor, and encouraged her to begin her journal in 1837. It was to Mrs. Hutchison that Sarah sent the introduction to the journal penned by "Ivor," a pseudonym of her friend John J. Blackwood. Susan Nye Hutchison herself kept a very detailed journal, chronicling her life from 1815 until 1841. Part of this journal survives and is in the Southern Collection at the University of North Carolina at Chapel Hill.

At the Raleigh Academy the young girls bloomed and Sarah excelled. She became proficient on the piano and the harp and graduated from the academy on November 5, 1819, receiving a medal for accomplishments in music. Their father had been elected to the U.S. Congress in 1818, and the girls probably joined him for a while in the city of Washington.

By 1837 Sarah was living at The Grove with her fifty-nine year old father who had retired from political activity, and was engaged in farming and gold mining. Her sisters were both married. Margaret's husband James H. Blake was from Washington D.C. They made their home in the village of Charlotte. Margaret gave birth to at least nine children, most of whom died in early childhood. In 1837 her children were Margaret Mary, Sarah Elizabeth and an infant Harriet Josephine.

Sarah's sister Harriet was married to Dr. David Thomas Caldwell of the Sugar Creek area of Mecklenburg County, three miles east of town, where they maintained their home. Harriet had four children when the journal was written; she eventually had four more. Their

The Private Journal of Sarah F. Davidson, 1837

house, Historic Rosedale, still stands and is now a historic site open to the public. Sarah's brother, William, later married Charlotte Malisa Gooch of Chester, South Carolina.

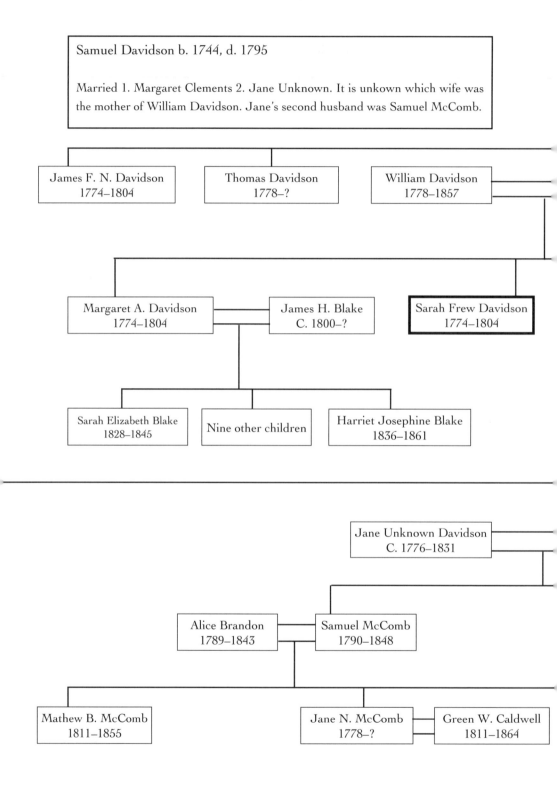

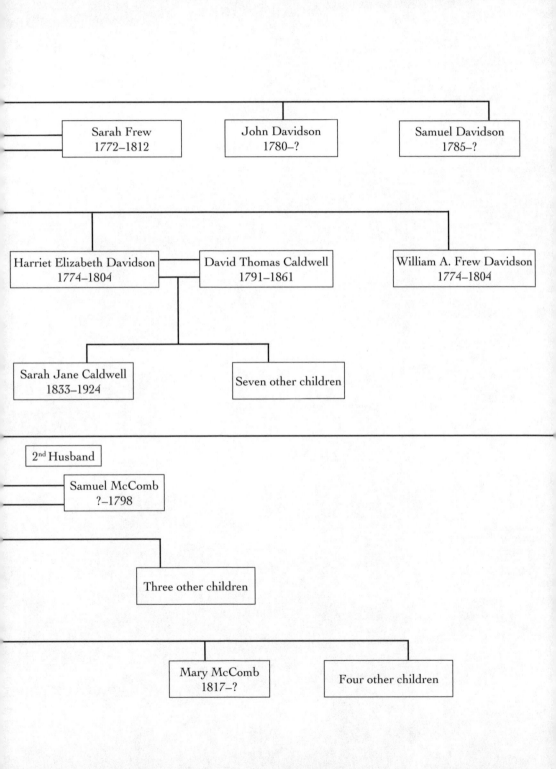

About the journal

Sarah Frew Davidson's handwritten journal is in the Caldwell and Davidson Family Papers in the rare books and manuscript collection of the J. Murrey Atkins Library at The University of North Carolina at Charlotte. It was recorded in a copybook measuring 7 ½" x 6 ¼" x ½". Its binding boards are covered with marbled paper of butternut, green, brown and black. The spine is covered in light brown leather. The pages are unlined manila paper sewn in eight signatures. Sarah wrote about twenty lines to the page with brown ink. Her handwriting is small and neat; every line is perfectly straight. The initial letters of "God" and "Christ" were generally written calligraphy style combining bold and fine pen strokes. The condition of the book is excellent except for the slightly worn cover, a bit of fading ink and light brown discoloration on the pages. There are no tears, but a tiny rectangle has been cut away from one page. A few sections were written in pencil and are difficult to read. This transcription faithfully duplicates the original. Sarah's journal contains very few misspelled words; most of the unusual spellings were correct at the time, and have been left in place. Contemporary abbreviations that Sarah used include "Do" for ditto and "&c" for etcetera. All punctuation, including parentheses, are from Sarah's pen. Bracketed words and phrases, footnotes and annotations were added by the editors. Sarah occasionally had a second thought and scratched through words she had written. Where the underlying text is illegible the editors have inserted [words crossed out]; all legible text is recorded.

A Life in Antebellum Charlotte

The introductory pages, entitled "The Past," were written by Sarah's friend John J. Blackwood, under the pen name "Ivor." He wrote in a well trained hand, very similar to Sarah's. The words "The Past" are underlined with decorative scrollwork. Sarah used the same scroll design and other decorative underlining in a few of her early entries. Blackwood's prose is flowery, effusive and somewhat convoluted, fashionable at the dawn of the Victorian era. It is a strong contrast to Sarah's more down-to-earth conversational style, especially when recording daily life. She does, however, lean toward lofty and ornate language when expressing her religious passions and frustrations.

Throughout the journal are hymn lyrics and poems, which Sarah used to express her thoughts and feelings on many subjects. Those that can be identified are attributed in footnotes; others may have been her own compositions, or familiar refrains, either copied or written from memory.

A few words were used differently in Sarah's time. Dinner was the main meal of the day and usually served between one and two in the afternoon. Tea or supper was a light evening meal. The word chamber refers to a bedroom. There are a number of dating irregularities in the journal. Sarah may not have had a calendar handy, and probably noted the date of the previous entry when beginning another. Consequently several strings of incorrect dates persist for a week or so. On some occasions the date seems to be that of the event she was writing about, rather than the day of the writing. Some entries may have been written over the space of several days. Bracketed dates, days of the week or locations at the beginning of the entries are the editors' interpretations.

A number of young ladies are mentioned whose identities cannot be confirmed, and who do not appear to be Charlotte residents. It is assumed that they are students of Reverend Leavenworth's school and are boarding at the school or in the neighborhood. Sarah commonly referred to people by their initials. This is simply a convenient shorthand, not an attempt to conceal identities. She mentioned at one point that she did not expect the journal to be read by others; she knew who she was writing about, which is all that mattered to her. The editors have identified as many as possible, and footnoted their names. It was commonplace at the time to address people, even close family members, by their surnames. Sarah used this convention, although she often used given names for intimates. It is not unusual to see the given name and surname for the same person interspersed in a single entry.

The Private Journal of Sarah F. Davidson, 1837

Each month of the journal is preceded by an annotation to add context and clarify some ambiguities. At the end of this volume are an epilogue, brief biographical sketches of Sarah's closest friends, a more detailed description of the Sabbath school movement and Holy Communion practices, and a discussion of gold mining and the Charlotte Mint.

Sarah F. Davidson's Private Journal

vol. 1
1837

The Past

In commencing a record where only by-gone events are to find a place, it is peculiarly appropriate to indulge in reflections on the past. --- Indeed that is the only one of the divisions into which time is often separated, upon which the mind can set in contemplation, gathering around her all the members of her mysterious council.----

Though the dark and deeply interesting future whispers that she has good to bestow hitherto unknown, yet at the same time she says it is wrapt in the folds of her drapery, which she weaves of uncertainty [something is written between the lines, too faint to read] and doubt. (But) By a law of Nature, we are forbidden to see an object which rests upon the organ of vision; so the very <u>nearness</u> of future things seems to prevent this discovery.--- Although our eyelids touch the vail that separates <u>now</u> from the wondrous <u>beyond</u>, yet the keenest penetration fails to enter: and should it succeed, no light falls upon the objects of its search, to return an image of their form and beauty. --- If we indulge fancy in painting pictures of bliss <u>to be</u>, many of the fairest are dispoiled of their beauty by the withering reflection that they may lie far beyond our graves----

Then, to attempt a contemplation of the future, merely to the end of our own time, is only to indulge in dreamy speculations which will pass away---

"Like the baseless fabric of a vision.----"[1]

The present, strictly speaking, has no existence.-- The great eternity to come is made up of moments; and these are continually bursting from the stupendous mass

[1] William Shakespeare, *The Tempest*

and rushing with fearful velocity to eternity that's past. We have our existence only in their transit.---

The past then, as we claimed in the outset, is the only portion of life upon which the thoughts find a substantial resting place.—Here any virtuous mind loves to linger and recall the days and incidents with an emotion kindred only to that awakened by the voices of long absent friends.-- Nothing is lost by distance in the retrospect.-- The law of mind, in this instance at least, seems to invest that which matter obeys, and makes objects glow with increasing light in proportion as they recede in the distance -- even down to the point where young Attention first conceived the design of etching her diary in rude, though distinct and significant characters, upon the unwritten tablets of Memory. —

The <u>whole</u> review of the past presents a chapter from which we may ever derive instruction and pleasure.--The instruction which experience imparts is allowed by all, to be of more practical utility, than volumes of untested theories.--- The attempt to mark the sources whence pleasures would be useless.--- Even our <u>errors</u>, when rightly remembered, are fountains, affording the richest draughts; for where is the enjoyment to be compared with the rich pouring -- out of the soul in broken emotions of penitence before God -- accompanied, as it ever is, with the secrets of forgiveness?

But besides the beauty of the whole together each part has separately, its peculiar good .-- The joyous scenes of childhood come up as bright as the cheerful winter=hearth around which they transpired. With no definite object in vision, we then grow weary of time, varied, as it was only by the lesson and the game. -- Stretching themselves between us, and the fancied delight, of riper age, and, as compared with what has then been our whole lifetime, the years seemed long indeed and moved as if upon leaden wheels.-- We now sometimes almost wish we could roll back the cycles to those days, that we might enjoy their scenes, and drink their sparkling cup again.-- We can but dwell with indefinable interest upon the glad actors in their scenes, as we trace the development of characters through subsequent life, and rejoice in the success, or weep over the calamities of each.

Then comes sunny youth --that spring=time of life, when ever=budding bliss is in fullest bloom, promising naught but golden fruit to the confiding heart.-- The warm gushings of youthful affection, and the ardour of early friendship, however unrequited or transcient, can never be remembered but with emotions dear to the bosom.-- But if in this interesting season the heart should be consecrated to God, and the fire of devotion kindled up on its altars, that point will ever lift itself, as the light at the mast=head of a beacon=ship, the brightest & loveliest of all the past.-- --Whatever lie may arrest the attention whilst reviewing this period of life, one thing never fails to strike the mind with painful fires, and that is the affecting contrast between the things we hope for and the things we have

The Private Journal of Sarah F. Davidson, 1837

enjoyed -- a contrast elsewhere never met, save at the point where struggling, half credulous reason is disentangled from the pageantry of some splendid dream.--

It is in the sober years of maturity that we now write; and of course, are ignorant of the effect which a review of these graver scenes will produce.-- However, this we know, that the remembrance of yesterday's hours -- mingling as they are, with those that went by, ere man was formed to note their flight, and swelling as they do the great ocean of past eternity -- presses down the mind with solemn & interesting reflections. --

Taking it for granted that all have enjoyed, and therefore appreciate the purest innocent pleasures to be derived from reminiscence, we deem it unnecessary to offer an apology for assisting memory, in her otherwise extemporaneous task, by the few notes of passing incidents which shall be found on the succeeding pages. --

<div style="text-align:right">

Charlotte 2nd Jany 1837----
Ivor.[2]

</div>

2 Ivor, John J. Blackwood, friend of Sarah's

Editor's Annotation
January and February 1837

The first section of Sarah's journal introduces many of the characters central to her life. Margaret Blake, Sarah's sister, and her husband James H. Blake were very close to her. The Blake's two daughters, nine-year-old Sarah Elizabeth, and thirteen-year-old Mary, often paid extended visits to The Grove where Sarah assisted with their education. Sarah's sister Harriet was married to Dr. David T. Caldwell; their plantation was about three miles east of the village.

The Reverend Abner Leavenworth and his wife Elizabeth Peabody Leavenworth were also close associates. Elizabeth's younger sister, Mary Ann Peabody, was visiting the Leavenworths at the time. Sarah referred to her as "Miss P" or "Miss Peabody." Sarah often turned to Leavenworth (or "Mr. L.") for spiritual advice, for she greatly valued his guidance and admired his preaching. She always called him Mr. L or Mr. Leavenworth, never Reverend.

Mary Davidson Elms was Sarah's cousin. William Davidson had become her guardian after her father's death, and Mary may have lived at The Grove before her marriage in 1836. Sarah lamented that the two were not so close as they had once been as single ladies. Mary's husband, W.W. Elms, co-owned with John Irwin one of the largest mercantile stores in the village.

Catherine Wilson Alexander was Sarah's closest friend. Catherine's late father had owned a plantation near The Grove. He had also owned a home in the village neighboring the Davidsons. Catherine and Sarah were childhood friends who became even closer while students at the Raleigh Academy. Catherine's father, like Sarah's, had been active in

state politics. Catherine's husband was W. Julius Alexander, a prominent lawyer in Charlotte who also served in the state legislature.

The Bissell brothers, Edward and J. Humphrey, were Connecticut natives drawn to Charlotte by the gold mining industry. Sarah enjoyed their company, especially Edward's, for intellectual stimulation. They shared a keen interest in natural science; however, Sarah was much distressed by Edward's spiritual ambivalence, and regularly included him in her prayers.

Sarah's most valued male acquaintance was John J. Blackwood. He was the "Ivor" who wrote the introduction to her journal. Blackwood was active in the church and the Sabbath school movement, and was acquainted with Mrs. Susan Nye Hutchison. Sarah referred to "brother B" several times during discussions of the journal and related correspondence between herself, Hutchison and Blackwood. "Brother" undoubtedly means brother in Christ rather than a familial relationship.

The events recorded in these early journal entries introduce the reader to Sarah's everyday life and her spiritual concerns. She wrote frankly of the quandary of teaching slave children to read. She eloquently described her earlier spiritual rebirth at a service conducted by the Robert Hall Morrison. During an 1833 revival, thirty-six new members were received into the congregation. This was probably the occasion of Sarah's awakening.

The importance of gold mining is reflected throughout the journal. William Davidson was one of a number of farmers who had found gold on his property and was actively involved in mining. In February, Sarah wrote of a horse that was found dead in a mine shaft on her father's land. This entry contains a brief, but informative, description of her father's gold mining business. She also reported seeking Sabbath school students in town among the poor miners' children. As an intellectual pursuit she reported reading *Bakewell's Geology*, the title which continued: *Intended to Convey a Practical Knowledge of the Science, and Comprising the Most Important Recent Discoveries, with Explanations of the Facts and Phenomena which Serve to Confirm or Invalidate Various Geological Theories*. The study of geology was of great interest in the gold mining community. Sarah's brother William and her brother-in-law James Blake were also heavily involved in mining.

Sarah's father had become ill the previous fall, and by February was nearly recovered. She wrote of having his feet bathed, which was done to

The Private Journal of Sarah F. Davidson, 1837

promote healing and comfort, and late in the month said he had returned to his chamber. It was customary for person who was ill to sleep in the bedroom of the family member who provided nursing care.

Sarah wrote of a chimney fire at the home of Levi Springs causing much commotion. Springs lived across the square from the Blake's home where Sarah was visiting. The threat of fire in the village was great, as most dwellings were built of wood. Chimney fires were common and flames could spread rapidly through the village. Firefighting by the volunteer engine company using water drawn from neighboring wells was not always successful.

January and February 1837

<u>Journal</u>.-- The Grove - January 21<u>st</u> 1837 [Saturday].

 There is a peculiar sweetness in the recollection of hours spent with <u>Friends</u> of a kindred spirit. -- Yet in commencing this Journal which is to be a record of incidents and feelings which <u>shall</u> or <u>may</u> occur -- I feel my heart oppressed and agitated with the varied emotions excited by the pains and pleasures of memory. -- Memory says M^r Lock[3] is at once the store house of our ideas -- for the narrow mind of man not being capable of having many ideas under view at once, it was necessary to have a depository on which to lay them up. In memory the mind is often times more than barely passive -- for it often sets itself to work to search some hidden ideas-- sometimes they start of their own accord -- sometimes tempestuous passions tumble them out of their cells. -- --- --- --- Retrospection -- the power of mind by which we recall the past has been busy -- examining the records of memory -ransacking her store house -- and presenting to the minds eye --with dazzling vividness -- scenes of the past: -- (but in each event oh Lord Thy ruling hand I see -- and why my soul art thou thus depressed) ---------------------- I will wait until they shrink into their respective cells and all is again calm and passive. -- And oh! may I soon regain my usual cheerful submission and

 In every joy that crowns my life
 In every pain I bear

3 John Locke (1632–1704), English philosopher and author of *Two Treatises of Government*

A Life in Antebellum Charlotte

Oh may I take delight in praise
Or seek relief in prayer.[4]

Feb^ry 1^st [Wednesday, The Grove]

This morning I was enabled by divine grace to renew the unreserved dedication of myself to God with <u>ardent</u> prayer, that my <u>whole life</u> -- with <u>all</u> wherewith He has endowed me may be <u>unreservedly</u> and <u>cheerfully</u> consecrated to His service. -- As the Sun disperses the mists and clouds which obscure his glory and vivifying power -- so the entire confidence and sweet submission (rays from this Glorious Sun of righteousness) that pervades my Soul has dispersed <u>all its</u> gloom.
"Oh! to grace how great a debtor."[5]
Being convinced that earth is not our abiding place -- and that all its enjoyments are fleeting and evanescent -- let me not look for unalloyed happiness in this transitory state -- but soar with all my first affections, directed by a firm unwavering faith --- to these <u>Realms</u> <u>above</u> <u>where</u> <u>alone is perfection of bliss</u>.

> *Lord send a beam of light divine*
> *To guide my upward aim!*
> *With one reviving touch of thine*
> *My languid heart inflame.*
> *Then shall on faiths sublimest wing*
> *My ardent wishes rise*
> *To those bright scenes where pleasures spring*
> *Immortal in the skies.*

Monday Morning

February - 6^th -- Saturday afternoon being mild, fair and pleasant
I walked to the Village[6] *accompanied by M^r. Blake*[7] *-- Sunday morning I went*

4 Prayer from *Hymnal of the Protestant Episcopal Church in America*, from poem of Helen M. Williams, 1786
5 Ruth 2:8–13; and from the hymn "Come, Thou Font of Every Blessing" by Robert Robinson, 1758. Appeared in John Wyeth's *Repository of Sacred Music*, 1813.
6 Charlotte, North Carolina
7 James H. Blake, Sarah's brother-in-law

The Private Journal of Sarah F. Davidson, 1837

to Sabbath school -- and then accompanied by Miss P[8] and M[r]. Patrick[9] went to the Baptist Church -- went home with Miss Peabody and once more enjoyed the society of our beloved Pastor M[r]. Leavenworth[10] who has been absent some months on a tour to the South. As there was no Teacher's meeting I spent a part of the afternoon with cousin Mary[11] and William Elms-- and after tea went with them to the Methodist Church. From the impressions received (There was no preaching in the Presbyterian from courtesy to the Baptists) from hearing such style of preaching -- concluded I derived <u>no benefit</u> and could be more profitably engaged reading -- at home. and therefore resolve never again to attend unless previously ascertained <u>who</u> was to preach. I also have to mourn being too much influenced by feeling confessed alone to God -- But -- do I feel He does with infinite wisdom order all my steps -- and that profit and instruction is received by my errors, "if rightly improved" and Oh may the Lord grant me grace to overcome every feeling the gratification of which may not be consistent with His holy will -- every secret sins -- and every appearance of evil -- Oh that my heart was purified from every sinful and defiling thought! -- Lord perfect Thy ways in me -- sanctify, and make me righteous and holy meet for Thy kingdom eternal in the heavens -- Thy holy habitation.

[Tuesday, The Grove]

Feb[ry] 7th-- Has been a delightful spring-like day -- walked in the garden -- commenced gardening -- and remained out nearly all day attending to the pruning of fruit trees and clearing away the decayed vegitation of the past year -- derived pleasure from observing the varied hues of the smoke and flame arising from the burning masses of heterogenous decayed matter—also observe some traces of renewed vegetation and could not but indulge in pleasing anticipations of approaching spring. After tea attended the instruction of our young servants[12] -- Being much troubled and perplexed (relative to my duty) on this subject -- and believing religious instruction cannot be well communicated without some knowledge of letters -- about six weeks ago -- I commenced learning them to read: -- and reading to them small portions of

8 Miss Peabody, sister-in-law of the Reverend Abner Johnson Leavenworth

9 Probably James Patrick, carriage driver

10 The Reverend Abner Johnson Leavenworth, minister of the Presbyterian Church at Charlotte

11 Mary A. Davidson Elms, cousin of Sarah and wife of William W. Elms

12 Slaves of Senator William Davidson

scripture and requiring answers individually on reading each verse. ----It is a source of peculiar gratification to find my feeble efforts to instruct has already produced a good effect -- and that the hours further spent by them in playing and strolling to the village has been devoted to acquiring knowledge. -- By their faithful attendance and application -- They can now -- repeat the Lords Prayer -- His commandments -- (and in the same degree understand) also can answer all the prominent questions which maybe asked on the 1st & 2nd Chapters of Genesis - and the 1st & 2nd chapters of Matthew - and progressing as fast as I can reasonably expect in learning to read. -- Ann -- Joe, & John spelling two syllables -- Lawson -- Leonidas -- John -- Jones -- Hampton -- Lawson -- in three letters -- Mary -- Tabitha -- Lena Lewis -- Mary -- Alonso - commenced spelling -- Marshall -- knows his letters.

[Wednesday, The Grove]

Febry 8th -- After my usual exercises of devotion and reading visited some sick Negroes -- Amanda (& Matilda) and the weather being still mild continued gardening -- whilst in the garden Mr. Edward Bissel[13] *in passing observed me, road up to the side of the enclosure and remained conversing some time -- relative to a religious paper -- (The Disciple) published in Tuscaloosa, -- Alabama -- several numbers of which he had sent me -- also -- on Geology -- a subject in which I have recently become much interested. It is indeed pleasing to observe the progress of science, -- may she still progress and receive every aid in her pursuit of knowledge -- collecting the scattered remains of exploded theories, or in the acquisition of new ones --. But when she dares to lay her sacrilegious hand upon divine truths which need not her attestation let every* <u>Christian</u> *counttenance be withdrawn. Mr. B.*[14] *- observed that Geological discoveries have already invalidated the writings of inspired historians -- and that finally the old Testament would not be regarded as the word of God -- but be classed among the other writings of antiquity merely for its historical accounts -- and poetic beauties. -- As he openly avowed his disbelief of The Holy Bible – the insurmountable treasures of every true believer I refuse to continue the subject --. --- Human Nature, -- Friendship between ladies and gentlemen - followed - and after making many inquiries about Friends - took leave - saying he would call soon again. - I returned to the house and found our chat had continued so long, - Pa*[15] *had dinner --. In the evening after my usual engagements - composed*

13 Edward Bissel, wealthy gold mine owner
14 Edward Bissel
15 William Davidson

The Private Journal of Sarah F. Davidson, 1837

a hymn to the words---.
> "All hail! The power of Jesus name
> Let Angels prostrate fall"[16]

[Thursday, The Grove]

Feb'y 9th My much loved preceptress[17] who prompted me to this work said to me let every day see <u>something</u> written - At present there is little variation either in my occupation or feelings - and the record of one day -- (generally) will answer for many -- Winter has again flourished his scepter. - and rules triumphant - I of course submit to his way - Gardening is no longer practicable - and sewing, reading, and &c &c[18] occupy my mind through the day Every night is devoted to our young servants[19] instruction it being the only time I can have them all assembled Practicing musick is my recreation.

Feb'y 11th [Saturday] Visited my sister (M'rs Caldwell[20]) - My visit was unexpected - She was not aware of it until I entered her chamber - and it more than compensated me for a cold ride on a disagreeable horse to observe how much she was gratified by my visit - When I returned home – found my friend M'r Blackwood[21] had <u>walked</u> from the Village to pay me a visit - I was truly sorry - Yet when I thought of the gratification my Sister manifested in the morning - I was content-

After tea (as usual) instructed the young servants[22] - and made some new regulation; - "To omit teaching Saturday nights["]- requiring them to prepare for the Sabbath - and so many as were able to attend preaching at the Church I attended myself, and for them to sit in the Gallery[23] opposite our pew, that I might observe how they conducted themselves. My Father[24] being much indisposed from a cold I had his feet bathed and sat up a while until all was still then with thanksgiving

16 Hymn written by Edward Perronet, 1726–1792
17 Susan Nye Hutchison
18 etc...
19 Slaves of William Davidson
20 Harriet Elizabeth Davidson Caldwell
21 John J. Blackwood
22 Slaves of William Davidson
23 Balcony where slaves were allowed to attend service
24 William Davidson

A Life in Antebellum Charlotte

and praise to Almighty God our heavenly Father and great Benefactor - for mercies received blessings bestowed and comforts & privileges enjoyed returned to rest.

Febry [Author's sequence is confusing]

Monday Morning
My mind is solemnly impressed this morning by reflecting on the fleetness of time - the measure of duration--- In its application to Earth our place of probation from the creation to the present period of its existence --- the length of time it may yet exist --- 5842 years has it endured to unceasing communion in the pathway marked out through infinite years by the great creator -- he did in faith during the mighty conception of the elements [illegible]. *After its* [illegible] *when the deluge swept from its surface All animate creation &c. did it press onward still onward the mighty emblem of man in his wild careen to destruction whilst -- his bosom is trembling naked & torn by a reproving conscience until God shall churn the dust of death to prepare him and thereby still the tempest of his sword the body returning to dust.- - and the spirits thus anointed* [illegible] *to the God who gave it's* [four illegible lines]

[Sunday, The Village]
February 12th Again enjoyed the priveledge of attending the Sabbath School of Charlotte - how very different are my feelings views relative to the blessed and sacred institutions from what they were when I first engaged in it --A Sabbath School was first commenced here by Mr. J. N.26 (afterwards an Episcopal preacher) none of them engaged as teachers (excepting Mr. N.27) were pious its existence was brief -- some other trials were made without effect. It was several years after this before I engaged earnestly in endeavoring to obtain an interest in Christ ---. A series of peculiar afflictions and misfortunes o'er whelmed my young and inexperienced heart - rendering it a wilderness or desert from which <u>every enjoyment</u> had fled. - <u>Long</u> did it remain infolded in the dark drapery of its intense misery. -- But our God is a <u>God of Love</u>. And will not he who tempers the mind to the shorn Lamb extend His helping hand to us (upon whom he has impressed his divine image -) When storms

25 Entry is written in pencil and very difficult to read.
26 Unknown
27 Unknown

The Private Journal of Sarah F. Davidson, 1837

of sorrow fall and sorrows of afflictions o'er whelm our hearts -- Yes! He will -- He does -- else would reason desert his throne -- the mind becomes a <u>wreck</u> – and Life a <u>blank</u>. --- For the space of nearly four years I was a stranger to the house of God -- It was during a communion season my steps were directed once more to hear His ministering servants proclaim His gospel truths. -- It was the Sabbath -- and a numerous congregation had assembled --- My situation was extremely painful from a rush of associated recollections and feelings and rendered me an apt illustration of the stony ground which afforded no soil for the seed sown to vegetate. The sermon closed e're my reverie was broken ---. Mr. Morrison[28] who was then our Pastor arose and with unusual animation delivered the processional exhortation to the administration of the Sacrament of the Lords Supper --. I will not attempt (indeed I cannot) describe the emotions of my soul whilst he with pathetic elequence -- as an ambassador for Christ – he entreated the assembled multitude especially those under his charge to be reconciled to God dwelling particularly on the love of God to us in Christ.-- Under the power of love my heart melted I longed to embrace Him and would gladly have risen and confessed my eager and ardent desire to be a follower of Jesus. -- Although from this time on my resolution was firm and decided to forget the things which were behind and reaching forth to those things which are before to press toward the mark for the prize of the high calling of God in Christ Jesus -- I saw -- but darkly -- the way of Salvation -- In my ignorance I imagined I could do something in returning the love of God -- before uniting myself to the Church. -- Stimulated by these feelings I exerted all my influence and powers of persuasion -- and finally prevailed with my female friends and acquaintances to join me -- in reviving the Sabbath School -- also formed & organized a Benevolent society --: Our Sabbath school was at first held in the Academy -- We invited Mr. Carrol[29] a man of professed piety -- to attend and open the school with prayer. -- Mr. Irwin[30] presented the books remaining from the school superintended by Mr. N.[31]: -- and the teachers supplied their respective classes with such as was particularly needed --

28 The Reverend Robert Hall Morrison, minister at the Presbyterian Church at Charlotte and Sugar Creek Presbyterian Church,1827–1833. In 1837 he was appointed first president of Davidson College.

29 Mr. Nathan B. Carrol, elder of the Presbyterian Church at Charlotte

30 John Irwin, Charlotte businessman

31 Mr. N. unknown

A Life in Antebellum Charlotte

The Benevolent society in the course of two years furnished funds for purchasing a Library -- about this time M^r. Leavenworth[32] was install'd as pastor of the Charlotte congregation - and our little school was regularly organized -- Officers elected &c. &c. -- I have learned -- long in this that it is not by works or righteousness we can do but that God according to His mercy saves us by the washing of regeneration and renewing of the Holy Ghost. Now, instead of being pleased and satisfied with what I Do -- I often feel that I do & have done -- nothing-- Oh for more diligence and unswerving faithfulness in doing all that is my priveledge to do.-- I have wandered far & now return to the incidents of the last Sabbath-- After SS was dismissed remained in the Church conversing with friends until the Bell rang for Preaching to commence -- In the afternoon -- accompanied by my particular friend M^r Blackwood[33] attended teacher's meeting at the house of M^r Leavenworth.[34] M^r L[35] opened the meeting with an appropriate prayer and it was concluded by a few remarks from brother B[36] - and then singing --

Father, what e're of earthly bliss [37] --- do.[38]

I did not join in the singing -- but it was a favorite hymn and when M^r Blackwood read it out and commenced singing it touched a cord that vibrated with sweet and pleasing melody in my heart ------- M^r L insisted that I should remain and listen to some passages from Pages Memoir. M^r. B[39] read some very interesting account--

M^r. B returned to M^r Blakes[40] with me -- & handed me a letter from M^{rs} H[41] which he had rec'd containing a message to me. -- I then left -- it was late -- & before I reach'd The Grove -- the lamp of night alone gave light --

32 The Reverend Abner Johnson Leavenworth, minister at the Presbyterian Church at Charlotte 1833–1838

33 John J. Blackwood

34 The Reverend Abner Johnson Leavenworth

35 The Reverend Abner Johnson Leavenworth

36 John J. Blackwood

37 Hymn "Father, What'er of Earthly Bliss" by Hans G. Naegeli, 1836 from *Hymnal of the Protestant Episcopal Church in America*

38 "do" means ditto

39 John J. Blackwood

40 James H. Blake, brother-in-law of Sarah

41 Susan Nye Hutchison, school teacher who taught Sarah at Raleigh Academy

The Private Journal of Sarah F. Davidson, 1837

[Monday, The Grove]

Feb\underline{ry}. 13\underline{th} - My Father intending to test the mine in The Grove had a windlass erected over a shaft which was sunk last Spring --- After it was made firm and a rope and bucket suspended - one of the miners (Wily[42]) descended and discovered there was something extremely offensive arising from the pit he call'd out (evidently alarmed) to those at the windlass who were letting him down to stop -- but finally acquired courage to descend and ascertain what it was -- to the astonishment of all -- it proved to be a horse -- It was with <u>much</u> difficulty and trouble taken out from a shaft thirty feet deep -- The horse belong'd to a poor man who had been searching for him more than a week. -- It was blind. -- how the poor creature wandered here, and thus perish, is truly astonishing -- "Whereas I was blind now I see"[43] -- is a passage of scripture which may be applied to many apparently trivial circumstances to the carnal or worldly minded. -- In the above circumstance I can (now) see cause for gratitude to God -- who has left nothing to chance-- but now rules <u>all</u> things with infinite wisdom. But for this timely discovery -- pestilential vapours would have arisen from the decaying and putrifying carcass -- creating sickness -- and the cause unknown: and if discovered at a later period -- The shaft which had consumed much time and labour in being sunk to its present depth must as a necessary consequence have been fill'd up. How <u>great</u> and how <u>good</u> is the <u>Providence of God</u>.

[Tuesday, February 14, The Grove]

14\underline{th} The Shaft being ventulated--- the mining opperations proceeded -- encouraging indications of a good mine

[Wednesday, February 15, The Grove]

15\underline{th} Came to water -- washed some of the ore which showed well -- according to the miners phrase --

[Thursday, February 16, The Grove]

16\underline{th} Rain'd nearly all day -- Engaged in reading Bakewell's Geology[44] -- and attending to the instruction of my little niece Sarah Elizabeth Blake[45] -

42 Wiley, a miner and slave of William Davidson

43 John 9:25

44 Robert Bakewell, *An Introduction To Geology; Intended to Convey a Practical Knowledge of the Science, and Comprising the Most Important Recent Discoveries, with Explanations of the Facts and Phenomena which Serve to Confirm or Invalidate Various Geological Theories,* 1833

45 Sarah Elizabeth Blake, daughter of Margaret and James H. Blake, niece of Sarah

- in Geography and Grammer -- I find patience an indispensable requisite in teaching -- This should teach me a lesson of gratitude of <u>unlimited</u> gratitude to the instructors of my early youth. Another lesson I may Learn -- is to teach -- and explain over over again -- with untiring patience -- and with gentleness and loving kindness -- for oh -- how <u>slow am I</u> to learn of my great Spiritual instructor -- who has given me line upon line precept upon precept -- here a little there a little – in ways <u>innumerable</u> --- Oh let me not be negligent and inattentive -- but hearken diligently to the voice of instruction that I may obtain the wisdom that is pure – peaceable -- gentle -- easy to be initiated -- full of mercy and good fruits.

[Friday, February 17, The Grove]
 17<u>th</u> How great is the priveledge of private or secret devotion -- and yet how little is it valued -- Oh my soul rejoice and praise God for the manifestation of his loving kindness and condescending presence this morning -- My heart melted -- I cast myself in entire and humble submission before Him and ardently entreated to be guided -- directed and disposed of agreeable to His holy will --- Oh holy heavenly Father leave me not to myself -- for I am prone to wander -- wander from the God I love -- My heart is fill'd with wickedness and deceit --but the blood of Jesus can cleanse and purify -- and the holy blessed Spirit can sanctify and now create the whole –

 To the dear fountain of thy blood
 Incarnate God I fly;
 Here let me wash my spotted soul
 From crimes of deepest dye
 A guilty, weak and helpless worm
 On thy kind arms I fall
 Be thou my strength and righteousness
 My Jesus and my all - —

 Finished reading Bakewells Geology -- how much more pleasing and profitable the perusal of this work would have been in conjunction with some friends equally interested but I will not repine and wish for what I <u>have not</u> -- but endeavour to be grateful and thankful for that which I have --Friends -- <u>highly gifted</u> -- pious -- some <u>eminently</u> pious ~~with~~ of congenial sentiments with whom it is my priveledge to commune unrestrained -- either in social converse or familiar epistleary correspondence --Yet notwithstanding these blessings -- there is a feeling at times that breathes a Spirit [illegible] to murmuring -- With a heart glowing with warm and intense feelings -- a heart formed for social affections -- I can not always refrain from dwelling too much upon earthly attachments

The Private Journal of Sarah F. Davidson, 1837

and although my heart returns (with interest) the love and kindly feelings of friends -- yet there is an aching void -- a void which nought but deep intense all absorbing love can fill -- May it be fill'd with the love of God -- which is higher than Heaven and deeper than Hell. -- In Him there is no variableness or shadow of turning ----------------------- Having schooled myself into a calm and contented frame I Again proceed -- About two o'clock -- the raining had ceased -- the clouds dispersed and the sun shining brightly -- Pa[46] walked to the hill and S. E. Blake[47] & myself rode to the Village -- found Mary[48] at Mc Blakes[49] -- after chatting some time we went to Mrss I & E store[50] -- received a friendly greeting from Mc. P[51] -- soon after Mc. I[52] made his appearance conversed with us until call'd away -- We returned to Mc Blakes[53] -- I commenced preparation for finishing a letter to my friend SW[54] when brother B[55] --call'd -- This poor Journal was in part the subject of conversation after the usual salutations and queries were over -- He had received a letter from Mss H[56] -- and favoured me with a perusal; -- until I read it and explained to him the contents, it was a complete enigma for it was at my request she wrote sooner than he expected -- and as she merely alluded to, without specifying the information received from me -- no wonder he thought her letter strangely incoherent -- Amongst the remarks in her letter -- she says -- I have read your elegant Introduction to my dear Sarah's Journal[57] and hope it is the prelude to a Journal of great merit -- It is mortifying to look over what I have scribbled and find not a sentence worthy to be read even by a friend --. I will at least endeavour to profit myself by it --or else there will be a loss of time paper and ink -- & I know the great Judge of all, over our most secret thoughts

46 William Davidson
47 Sarah Elizabeth Blake
48 Mary Elms, cousin of Sarah
49 John J. Blackwood
50 Irwin and Elms Store
51 Probably James Patrick, carriage driver
52 Mr. John Irwin, co-owner of Irwin and Elms Store
53 James H. Blake
54 Sarah A. Williamson from Lincolnton, North Carolina
55 John J. Blackwood
56 Susan Nye Hutchison, school teacher who instructed Sarah at Raleigh Academy
57 Journal of Sarah Frew Davidson (this journal)

and acts -- allows me to use every means for the improvement of the talents He has entrusted to my care My Journal I will continue notwithstanding its want of interesting matter -- as it is to be my aid in self examination To be as it were a Mirror reflecting my dayly walk through life -- A Beacon to guard or warn me from the dangers and difficulties passed in my lifes troubled eventful way -- and in conjunction with my holy blessed Bible to be my pilot and guide through those yet to come. --How many troubles, trials, afflictions, and dangers I have already passed -- Thy goodness O Lord has been <u>great</u> Thou hast ever been my deliverer -- but often was I ignorant of the source from whence I received aid in the time of my greatest need -- Praise and glory unto Thee for thy condescendsion in making thyself know to such an unworthy creature as I am -- Oh Holy Heavenly Father -- <u>fill</u> my soul with gratitude and love –

[Sunday, February 19, The Village]

19<u>th</u> After I went to the Village - finding it earlier than usual sent for M^c Patrick[58] and rode to the Charlotte Mine[59] in search of Sunday school schollars -- took up three poor little children in the carriage and received the promise of four grown girls and the regular attendance of all so long as they remained in their present abode -- We then hastened back to the Village and arrived at the church in time for Prayer -- Heard an excellent sermon from our beloved Pastor M^c Leavenworth[60] -- from this text -- "Except your righteousness shall exceed the righteousness of the scribes & Pharasees, ye shall in no case enter into the Kingdom of Heaven["][61] -- A sermon well calculated to induce self examination -- May we all engage in this work -- with our Bibles before us -- and our souls raised in supplication to God for the Holy Spirit's aid -- and oh may we all find our righteousness in Christ -- for whosoever buildeth upon this rock -- shall not be moved -- but shall endure forever –

[Monday, February 20, The Village]

20<u>th</u> Visited my sister M^{rs} Blake[62] ---

58 James Patrick, carriage driver

59 The Charlotte Mine also known as St. Catherine's and McComb's Mine

60 The Reverend Abner Johnson Leavenworth, minister at Presbyterian Church at Charlotte

61 Matthew 5:20

62 Margaret Davidson Blake, sister of Sarah

The Private Journal of Sarah F. Davidson, 1837

[Tuesday, February 21, The Village]

21*st* M*rs* Alexander[63] *and myself went round as collectors of the Missionary fund -- It being court week -- people were too much engaged in worldly gain -- to think of the cause of Christ -- the streets thronged with all classes -- Met some who professed interest in the Redeemer's kingdom, but said their contributions must be reserved for their respective Churches -- I fear I talked too much and was not sufficing thankful for the little we received -- It was my first attempt -- Finding it an unfavourable time we defer'd further collection for another day -- May the experience of this day be improved -- and when we again apply to the tennants of the Lord of all -- May every one give as they have received. Cousin Mary Elms*[64] *returned home with me- - and as we once more engaged in our usual occupations -- the reccollection of the severed associations (by her marriage) of our long intimacy had a depressing influence: -- but far be it from me to indulge in one thought of regret -- for although* my social enjoyments *are* diminished *thereby* her happiness is increased.

[Wednesday, February 22, The Grove]

22*d* *Received a letter from my friend S. Williamson*[65] *with a flattering promise that I shall soon have the pleasure of enjoying her society --- Also my friend Ada*[66] *and Harriet*[67] *-- Sarah*[68] *-- letter gives the cheering intelligence of new born souls --- and among them my cousin M M-Culloh*[69] *In praying for my kindred M*[70] *has been ever remembered though not in a special manner -- Never do I bow before a mercy seat without pleading for* relatives *--* friends *and acquaintances -- The work of grace has commenced oh may it continue until all & each one shall be made anew in Christ Jesus. -- She says several members are added to the Church and the people, -- particularly the young are much interested on the subject of religion When will the people of Charlotte awake from their drowsy slumbers-- and live and act for Eternity -- This world this wicked world with its transient -- fleeting enjoyments*

63 Elvira Catherine Wilson Alexander, wife of William Julius Alexander
64 Mary Elms, cousin of Sarah and wife of William W. Elms
65 Sarah Williamson of Lincolnton, North Carolina
66 Adeline Ramsour of Lincolnton, North Carolina
67 Harriet Ramsour from Lincolnton, North Carolina
68 Sarah Williamson of Lincolnton, North Carolina
69 M. McCulloch, unidentified cousin of Sarah
70 M. McCulloch

occupies too much of our time and thoughts. I am guilty and can say nothing to any one as reproof. Oh that I could live -- so that my conversation and walk through life would constrain all to know and believe that I am what I profess to be -- a follower of Jesus – this would be reproof that would be effective -- But alas -- I come short in every duty -- and find my heart throbs too much for worldly enjoyments -- for all are worldly that are not heavenly

[Friday, February 24, The Grove]
 24th Mary[71] has left and I am again alone so I was disturbed this morning -- engaged in reading a portion of Scripture and enjoyed the blessed priveledge of communing with my God -- and although indisposed from head & ear ach attended to my night school[72] with an unusual degree of calm and quiet pleasure -- conversed a while with my Father and retired. He once more occupies his own chamber -- he has slept in mine since his illness last fall until now.

[Saturday, February 25, The Grove]
 25th Wrote a letter to Mr. Elms[73] -- and as my friend Catherine[74] is sick must make preparation for leaving home -- and visit her -- Arrived in the Village call'd a few minutes to see Mary[75] & then rode on to M[rs] Blakes[76] -- found little Mary[77] sick-- Sent for M[r] P[78] -- gave him my letter to M[r] Elms[79] -- And heard from him an interesting account of a prayer meeting the night previous -- As the children were not well concluded to remain with them until after Tea -- Whilst waiting for my brother[80] to accompany me to M[r] Alexanders[81] -- I walked to the door and raising my eyes to the Heavens [words crossed out] *-- whilst gazing at these brilliant orbs &*

71 Mary Elms, cousin of Sarah
72 Night school, teaching her slaves to read
73 William W. Elms, husband of Mary and co-owner of Irwin and Elms store
74 Catherine Wilson Alexander
75 Mary Elms, cousin of Sarah
76 Margaret Davidson Blake, sister of Sarah
77 Mary Blake, niece of Sarah
78 James Patrick, carriage driver
79 William W. Elms, postmaster
80 William F. Davidson
81 William Julius Alexander, husband of E. Catherine Alexander

The Private Journal of Sarah F. Davidson, 1837

my mind deeply absorbed in speculation and wondering thoughts & immaginations -- I was suddenly aroused by a blaze of fire issuing from a block of buildings across the street -- The cry of fire ringing of bells -- calls for the Engine and fire company ---the citizens running alarmed me and I too ran out in the street -- It proved to be an accidental burning of M[rs] Springs[82] chimney ---- I returned to the house -- and M[rs] Blake[83] and myself remained on the plattform -- M[r] Blackwood[84] joined us -- we were alarmed & he had been running -- and it was amusing to listen to the laboured attempts at conversation -- whilst the lungs were regaining their natural action -- M[r] B soon left us and we then together ~~again~~ directed our attention to the splendidly, luminous canopy of nights star spangled banner which moved <u>high</u> above us --The air growing cold we went into the house and being seated by a <u>social fire</u> we -- had a long social and confidential chat – about nine o-clock he rose to take leave -- M[rs] Blake[85] had been sitting a short time with us -- and knowing M[r] Blake[86] had retired -- asked me if I was going to stay with M[rs]. Alexander[87] -- I replied softly -- in the affirmative -- but not soft enough to escape the quick ear of brother B[88] -- who after chiding me for being so formal, accompanied me to my friend Catherines[89] residence --I found her better than I expected to see her – She kissed me and then throwing back the quilt and clothing of her bed I discovered or rather saw for the first time her fourth daughter[90] -- about five days old. -- I did not retire until after 12-o-clock and occupied a bed in the same chamber -- as to be convenient if she required attention through the night.

[Sunday, February 26, The Village]

26th -- On entering the Church to attend Sabbath School was much gratified to find the schollars who promised on Sabbath previous to attend the School -- already in their places --several other new schollars enroll'd --. Our School is indeed

82 Mary Amanda Moore Springs, wife of Leroy Springs
83 Margaret Davidson Blake
84 John J. Blackwood
85 Margaret Blake, sister of Sarah
86 James H. Blake
87 Catherine Wilson Alexander
88 John J. Blackwood
89 Catherine Wilson Alexander
90 Daisy Alexander was born February 20, 1837, to Catherine and William J. Alexander.

increasing in number -- but is it prospering -- The schollar's no doubt increase in knowledge -- but is it that knowledge which shall never be taken from them --but will continue to increase and grow brighter and brighter until they shall know the height and depth of the love of God in Christ Jesus as the glorified heirs of His redemption? O Lord let them not strive merely for the acquisition of knowledge -- but bless unto them the means of instruction and make them wise unto Salvation

Editors' Annotation
March 1837

Sarah and her friend Catherine were obviously pleased at the prospect of a visit from their "Preceptress," Mrs. Susan Nye Hutchison, who was teaching at the Salisbury Academy. Unfortunately they were disappointed. The journey from Salisbury to Charlotte required an overnight stay. Mrs. Hutchison had planned to spend the night in Cabarrus County with the Frew family, cousins of Sarah. Illness in the Frew family prevented the visit.

Sarah was an excellent musician, and as a school girl received awards for her musical accomplishments. She performed on the piano for friends with great pleasure, but her keen appreciation of music caused her to dislike giving lessons. Playing by unskilled children apparently grated on her ear, yet she taught because it was her Christian duty. Ironically, in 1839 when Mrs. Hutchison opened a female academy in Charlotte, Sarah became its music instructor.

A March journal entry introduces another of Sarah's close friends, her twenty-year-old cousin Mary McComb. Mary's father Samuel, stepbrother of William Davidson, was one of the town's principal miners. Mary had six siblings, including Elizabeth, a piano pupil of Sarah's. These cousins were mentioned throughout the journal, but none were as dear to Sarah as Mary.

Sarah's journal provides a look into the institution of slavery in the piedmont of North Carolina. Her father, one of the county's largest slaveholders, owned about eighty enslaved Africans. Sarah, like her contemporaries, nearly always called them Negroes; the word slave is rarely seen in documents of the period. She referred to those who worked

in her father's home as "servants" which was the common term for slaves who did domestic work. The physical and spiritual health of the slaves was Sarah's responsibility as mistress of her father's plantation as she faithfully visited and ministered to the sick. Especially touching is Sarah's tale about the illness and death of Amanda. At Sarah's invitation two doctors, the minister and several friends visited the dying slave. Sarah supplied spiritual comfort and agreed to care for Amanda's children, Lawson and Mary.

When Amanda died, Sarah saw to the preparation of her body for burial, and the entire event is described with loving concern. The funeral was held at night. This was an African tradition which was also practical in a slave owning society. Slaves from neighboring plantations could attend an evening funeral which certainly would have been prohibited during working hours. Amanda's service was on a Sunday when slaves had leisure, yet it was still held in the moonlight.

Lucy was another elderly slave who was ill in March. Sarah believed that Lucy's salvation was assured, though she had not been completely certain about Amanda's. She was overjoyed that she had been the instrument of Lucy's salvation.

Sarah's father was thrown from a horse, a common accident of the time. Ironically he died twenty years later after being thrown from a carriage. Sarah was concerned that her father's cold disposition reflected his lack of religious conviction. He reassured her that his Christian beliefs were sincere. His worries were financial ones. The Charlotte branch of The Bank of New Bern, where Davidson had been cashier, had closed in 1832. Lingering problems from that venture may have plagued him. The senator also had financial problems involving a brother. The nature of the problem and with which brother is unclear. It may have concerned mining interests with his step-brother Samuel McComb.

March 1837

 March -- Numerous and pressing engagements has prevented me from recording the incidents and feelings of last week --- Some of a pleasing nature which I shall love to cherish --- & others I would forget --- But where the heart is <u>much</u> <u>excited</u> by pleasing or painful emotions --- Memory requires no aid in reviving their recollection --- and the hand of time has not power to erase, --- their deep impression.

[Saturday, The Grove]
 March 11<u>th</u> Received a note from my friend E. C. Alexander[91] - (with a letter from our beloved Preceptress[92] containing, the pleasing intelligence - that she designed visiting us) requesting me to go in and receive her as she is yet confined to her chamber. --- In the afternoon L Springs[93] E McConnougha[94] and E McComb[95] came out to receive some instruction in Musick. Nothing but necessity or being convinced duty requires it will I ever become a teacher of Musick --- It is one source from which I derive unalloy'd pleasure -- and I find my ear & taste for Musick dayly becomes more fastidious. It has become a fashion or custom for all who are able to bear the expense to learn Musick regardless of ear or taste for it and consequently whosoever

91 Elvira Catherine Wilson Alexander (Catherine)
92 Susan Nye Hutchison
93 Laura Springs, daughter of Leroy and Mary Amanda Moore Springs
94 Eugenia McConnaughey, probably daughter of Joseph and Mary Locke McConnaughey
95 Elizabeth McComb, daughter of Samuel B. and Alice Brandon McComb

under takes to teach promiscously must not only be disgusted and lose their own relish for the divine art --- but will fail in teaching such to become even ordinary Musicians --- and will sometimes fail in teaching them to play one piece of Musick in harmonious time -- much less to play with taste & Spirit. -- Yet I am willing to assist any of my young friends whose desire is so great as to induce them to walk here a distance of two miles to obtain my poor assistance.

[Sunday, The Village]

March 12th Heard a sermon from an Irish immigrant containing much good sense --- & though in the plainer style - well & happily illustrated - but - oh this wicked heart I fear pants more for well dressed food and exciting spices than it does for the pure simple milk of the word. Yet I trust I shall ever treasure up in my soul the truths of the Gospel and be ready to receive with gratitude its administration --- and cheerfully obey its instructions--- I have to mourn my coldness - my wandering thoughts - earthly feelings - doubts - in one - a troubled heart --The teacher's meeting - thinly attended -- my feelings here were even worse than this morning --- A Friend accompanied me nearly home - and as we rode his pious conversation strengthened me - his presence calmed the doubts that troubled me --- for it was suspicion of sincerity created by circumstances too trivial to record & of which I am now ashamed ---Oh for more grace & heavenly mindedness --- then will these earthly troubles cease to trouble --- for were my heart fixed on God alone --- then would I have no other desire -but to do His will. For this I will strive & may the Lord grant me the aid of His holy Spirit

[Monday, March 13, The Grove]

13th Looked anxiously for M̲c̲ L[96] to visit poor Amanda[97] whose mind is distressed with recollections of the exceeding sinfulness of her past life --- I have given her all the consolations & instructions as far as my limited capacite enabled me --- & she appears more composed - It still rains --- M̲c̲ L will not be here and I must soon leave to meet my beloved preceptress.[98]

96 The Reverend Abner Johnson Leavenworth, minister of Presbyterian Church at Charlotte
97 Amanda, slave of William Davidson
98 Susan Nye Hutchison

The Private Journal of Sarah F. Davidson, 1837

[Wednesday, March 15, The Grove]

15th -- Oh how great is the goodness of God how shall I voice my gratitude and love for His innumerable blessings and mercies -- My Father has been thrown from his horse & through the merciful protection of Providence his life is preserved -- His horse not only threw him but also fell & in falling fell on his (Pa's) leg and much bruised & lacerated it -- & although this is a serious evil by which he suffers much pain -- Confined to the house -- unable to walk -- &c - yet I can only think of his preservation & exercise my soul in thanksgiving to His Almighty Preserver. -- ----------This circumstance has prevented me thinking of the disappointment we felt in not seeing our beloved Preceptress[99] who was prevented from visiting us by the illness of the Frew[100] family with whom she designed coming. On Monday & Tuesday nights I attended Mr McKee'-[101] Lectures -- & every day returned home accompanied by M- McComb.[102] -- Found poor Amanda[103] evidently worse & her strength rapidly declining.

[Thursday, March 16, The Grove]

16th Sent the carriage for my sister Mrs Blake.[104] It is now four months since she was here - owing to her recent confinement[105] and the inclemency of the weather.

[Friday, March 17, The Grove]

17th -- Dr Harris[106] & Dr P-C Caldwell[107] were here this morning & visited Amanda -- they confirm my aprehensions of approaching dissolution-- Sent for Mr L[108] and endeavored to prepare her to receive the tiding of the speedy cessation

99 Susan Nye Hutchison
100 Family of Archibald Frew, uncle of Sarah Davidson
101 Mr. McKee, unidentified
102 Mary McComb, cousin of Sarah
103 Amanda, slave of William Davidson
104 Margaret Davidson Blake
105 Harriet Josephine Blake was born November 19, 1836, to Margaret and James H. Blake
106 Dr. Thomas J. Harris, partner of D.T. Caldwell and P.C. Caldwell (not related)
107 Dr. Pinckney Coatsworth Caldwell, partner of Thomas J. Harris and D.T. Caldwell
108 The Reverend Abner Johnson Leavenworth, minister of the Presbyterian Church at Charlotte

of her earthly sufferings – which have been - great - and much protracted. M^cBlake[109] & M M^cComb[110] - visited her before they left--in bidding them fare-well -- she uttered good bye as if she was saying it to them for the last time. After they left I remained with her -- She asked for her children and when they were brought to her she committed them especially to my care. Oh Lord grant that I may be faithful to this dying request of a valued servant. To order all things relative to me that I may be enabled to train them in the way that leads to eternal life--and administer to their earthly wants. Unto Thee my God I look - on Thee will I depend -- For them who put their trust in Thee will find that Thou art a very present help in every time of trouble –Thy grace & strength is sufficient for all things -- and I shall be able to do all things acceptably to Thee through Christ who strengtheneth me -- This dying request affected more than I can express &I sensibly feel the weight and responsibility of the trust confided to me. M^c L[111] came between 3 & 4 o.clock -- a sudden storm of wind and rain prevented his seeing Amanda[112] immediately when it was over we went together to see her. She was too far spent to talk - but so satisfactory were her answers brief as they were - we have hope in her death. M^c L remained with us until after Tea – I enjoyed his intellectual conversation much – Yet - I feel I am somewhat selfish about the friends I love - I always desire to have them alone - then I feel no restraint my soul flows out - indiscreetly confiding its secret feelings to their inspection - and instruction - consolation - sympathy or encouragement - &c - is received -- & As this is to me one of the sweetest priviledges friendship bestows - when denied or debarr'd from this pleasure I am under painful restraint -- & the enjoyment of their society is much diminished. But when we enter this blissful abode of Christ's redeemed -- all restraints will vanish -- all will be of one mind -- engaged in the same pursuits -- no sin -- no temptations -- no doubts perplexities or cares -- to disturb us -- Love – redeeming love shall fill every heart -- be the theme of every tongue-- the subject of our adoring praise throughout the countless ages of a blissful Eternity -- We shall be with Christ -- His presence will perfect our joys & happiness. How many of those who are

109 Margaret Davidson Blake, sister of Sarah
110 Mary McComb, cousin of Sarah
111 The Reverend Abner Johnson Leavenworth, minister of the Presbyterian Church at Charlotte
112 Amanda, slave of William Davidson

The Private Journal of Sarah F. Davidson, 1837

on Earth united by the ties of affection -- when death shall separate will reunite around the eternal Throne of God! Alas! who can say - God alone knows His redeemed -- Am I one of them - & how many of those dear to me are the hopeful heirs of Eternal life. Oh Lord -- give me the spirit of prayer -- faithful prayer.

[Probably Sunday, March 19, The Grove]

 18th Sabbath -- Amanda' -- Spirit (as we every reason to hope) winged it's flight to the realms above prepared by Christ for His redeemed souls - between 2 & 3 o'clock this morning--I was up nearly all-night -- & being indisposed lay across the bed -- I did not engage in my morning devotions but whilst I thus lay - meditating - my soul breathed its silent aspirations - and never did I feel more powerfully the love of God shine abroad in my heart -- Oh it was a time of sweet enjoyment -- Oh that I can ever feel thus - calm & serene -- My soul glowing with love -- & all day long -- My heart was mostly tempered -- Mary came out & brought Amanda' shroud; we shrouded her -- & thus awaited the coffin -- it came -- & after seeing her placed in it -- & arranging the little pillow under her head we retired --& when the procession of friends & acquaintances who had come to pay their last tribute of respect - & attention to her earthly remains -- moved in respectful order to the place of interment-- we also followed the corpse to its grave -- Mary left -- & I was alone with my Father. The negroes held a prayer --meeting -- It was bright moon light night - & I walked in the piazza - how still & solemn does all nature appear at night after witnessing the death of an immortal Being - especially - when we have long been with them - esteemed their character or in any way feel their presence conducive to our happiness --This night I shall ever hold in remembrance – walking in the piazza - the bright clear silver light of the moon rendered every object distinctly visible. - Not a leaf was moved by the gentle breeze that sighed as if in sympathy with those that mourned --I felt an indescribable solemnity & awe - that seemed to stay the opperations of the mind -- & produced a vacuity of thought -- I paused to listen to a faint sound - which swelled louder & louder as it was born along. -- It was the sound of a mans voice -- I listened attentively – It was a voice uttering loud & fervent prayers -- how Thrilling -- Is it the prayer of faith – then will it be wafted to the Mercy seat above - received- answered - & ministering angels - sent to bestow the boon -- granted by the intercession of Christ – whoever liveth to make intercession for fallen ruined man -- reclaimed - & saved by His glorious atonement from the wrath & indignation of an offended God & Creator ----. Oh may this solemn visitation of Providence be blessed & sanctified to all connected with our departed servant - as relatives - friends acquainttances & fellow servants.Talked much with my dear Father -- I summoned resolution to ask relative to his own religious

state. Oh how much relief did this conversation offer me -- His apparent coldness & indifference all satisfactorily explained-- My heart was soothed his case so far from being such as to excite my fears called for intense sympathy -- Oh gracious & Almighty Father - if it is not inconsistent with Thy holy will grant that he may soon be relieved from all his pecuniary difficulties -- May his brother[113] be brought to a just sense of his unjust treatment - of ever who has been more than a mere brother to him -- But if his kindness & benevolence is not to be receive any of its reward here --enable him to bear every remorse of earthly enjoyments - with christian resignation submission & cheerful contentment -- & ever give him grace for every time of need - guide & direct him by Thy good Spirit – bless & protect him -- & finally when it shall be Thy holy will to call him hence - receive him into Thy kingdom above. All of which I ask in the name & for the sake of Jesus Christ our adored & blessed Redeemer.

[Probably Monday, March 20, The Grove]
19ᵗʰ Whilst preparing the dressings for Pa's leg - was surprised by an early visit from Mᶜ Irwin[114] *-- soon after Mᶜ. Perry*[115] *- After I dressed the wound on Pa' leg walked to the garden - gave some directions - & seeing another visitor approaching the house returned -- Procured some seed & again repaired to the garden accompanied by Mᶜ I. -- who after some little pleasantries & jests took leave. Visited a sick servant (old Lucy)*[116] *- poor old woman her pilgrimage is nearly o'er - she requested me to read the Bible to her. I did so -- & I humbly trust her repentance & faith are genuine & evangelical - in strict accordance with the evidences of all christian experience -- she told me I was the unworthy instrument in the hand of God in leading her to repent & turn unto the Lord -- And have I been this honoured glorious thought! My heart is o'erwhelmed -- can it be so I know it can -- Oh Lord -- thine is the glory -- all our good works are but reflections caught from Thee -- & thine alone the praise - it is glory enough - & far more than I deserve to be in any degree <u>Thy</u> humble handmaid - to Labour in Thy cause - & have my feeble efforts to serve Thee crowned with Thy blessing. My heart is full -- but other duties closes the present effusions of my poor pen. Be with me Oh Lord & help me to discharge every duty as becometh thy disciple. ---------*

113 Unidentified
114 John Irwin
115 Andrew J. Perry
116 Lucy, slave of William Davidson

The Private Journal of Sarah F. Davidson, 1837

[Probably Tuesday, March 21, The Grove]

 20th Indisposed from a cold --. Soon after breakfast Mr I[117] - again made his appearance -- & remained until after dinner -- Mr Blake[118] also dined with us today. Before Mr I left he again assisted me in dressing Pa's sore leg --- He is certainly the best nurse I ever saw -- He amused me with some of his jovial remarks & when I had a good opportunity retorted - for his provoking bandinage - all in jest & good humour. ----At the close of day there being indications of a storm & not feeling well -- I did not assemble all the young servants as usual -- Those that live near the house I gave permission to recite their lessons in my chamber -- We were busily engaged when a sudden & most violent squall of wind rain & hail caused every one in the house to rise from their seats in alarm - for the result - with considerable difficulty -- Lawson[119] & Joe[120] closed the out doors --. & then all clustered promiscuously around the fire – all restraint which is ordinarily manifested by them vanished & each one expressed himself as he probably would have done in their mothers cabin. After the storm abated -- I examined them in what they have been learning since the 1st of January --Pa was pleased -- & thinks they are making good progress. May it be for their eternal good & not for vain show of a little knowledge. Before we retired to rest -- all was calm -- the dark clouds had passed away & the silvery orb of nights resplendent lamp - shone clear & bright.--- What a beautiful emblem of an humble obedient Christian steadily pursuing the course prescribed by the Almighty shedding the reflected light from the Sun of Righteousness upon all around.

[Probably Wednesday, March 22, The Grove]

 21st Another call from Mr I.[121] He informs us Mr Elms[122] has returned --. Mr Blake[123] & brother[124] William were also to see us this morning ----Visited old Lucy[125] & endeavoured to prepare her for making ready to receive the summons of death to

117 John Irwin
118 James H. Blake, Sarah's brother-in-law
119 Lawson, slave child of Amanda
120 Joe, slave child of Lucy
121 John Irwin
122 William W. Elms
123 James H. Blake, brother-in-law of Sarah
124 William Frew Davidson, brother of Sarah
125 Lucy, slave of William Davidson

give in her account of the deeds of her body to her great & Almighty Judge -- Creator & Saviour My knowledge is little - Yet it is more than I deserve and more than I fear I rightly impower -- In my efforts to instruct -- console and encourage Lord be Thou my help & all shall be well -- In endeavoring to lead souls unto Christ -- let naught obscure my vision -- may I see clearly the way -- that I may not be as the blind leader of the blind

[Probably Thursday, March 23, The Grove]

22d Mary[126] and Mc Elms came out and stayed all night. After Pa retired we had a social and confidential chat -- partook of some refreshments and retired to our chambers --- Oh that I could say after family worship --but I trust that (although not collectively) every heart embraced the blessed priviledge of pouring out its thanksgivings and petitions before a mercy seat before the eyes were closed in sleep.

[Probably Friday, March 24, The Grove]

23d After an early breakfast – M -- & Mc E.[127] Left After dressing Pa' -- wound & examining my little niece S.E. Blake[128] on geography -- visited old Lucy -- & attended a little to gardening -- felt unwell - & reclined a short time on the bed. Oh what a poor weak erring creature I am -- how many thoughts arise I would hate to utter -- how groveling are all thoughts & ideas when they refer only to time. Nothing is exalted -- but what must in some degree have reference to Eternity -- all else -- is what -- nothing -- ah less than nothing - yet foremost to render an account of every deed & thought howsoever trivial and unmeaning -- Who could bear to see their own heart with all its corruptions -- from all but God alone is hid the nakid deformity of a human heart. With this imperfect view I have of the depravity of my heart -- My soul would be embittered with desponding fears -- but for the hope that is founded on Christs redemption assured by faith. -- Oh glorious scheme of Gods salvation through Christ by which Mankind shall again be restored to holiness & the enjoyment of his presence <u>for-ever</u>. O Lord increase my faith --. Let not I pray thee the deep sense of the wickedness of my heart obscure with clouds of doubts & fears the bright rays emitted from hope this guiding star of the christian's faith – whilst tossed on the sea of life. –

126 Mary Davidson Elms, cousin of Sarah
127 William W. Elms
128 Sarah Elizabeth Blake, daughter of Margaret and James H. Blake

The Private Journal of Sarah F. Davidson, 1837

[Date Correct, Saturday, March 25, The Grove]
25th Received a visit from M. A. I.[129] in the morning --and in the afternoon Miss Dyott[130] -- Mary[131] & Sarah Alexander[132] & Mary Wilson.[133]

[Sunday, March 26, The Village]
26th Pa being better -- I attended Sabbath School -- & Preaching -- but returned before Teacher's meeting. Nothing worth revealing transpired -- Some little incidents of a pleasing character occurr'd - but rather of feeling than action that I shall certainly <u>remember</u> without the aid of my Journal.

[Monday, March 27, The Grove]
27th Calm & serene -- May I now strive against the petty troubles that have so much disturbed me of late. Oh -- holy heavenly Father purify & sanctify my heart -- & may it only throb with feelings sweetly submissive & attuned to Thy holy will. Engaged in Teaching S. E. B.[134] and having The Grove cleared of leaves -- & rubbage.

[Tuesday, March 28]
28th In the afternoon rode to the Village -- Mrs Blake[135] being at Mrs Springs[136] -- I walked over to see her & after spending a half hour very pleasantly returned had a delightful ride (alone) which exhilerated my spirits -- the exercise of riding fast has always this effect upon me. -- My frame of mind quiet & calm before the hour of rest - & enabled me to enjoy in the solitude of my chamber my evening devotions.

[Wednesday, March 29, The Grove]
29th Wrote a letter to My Dear Preceptress[137] Mrs Hutchinson -- in reply to one received from her in which she requested an immediate answer -- I esteem it quite a

129 Mary Ann Irwin, daughter of John Irwin
130 Miss Dyott, student at the Charlotte Female Academy, living with the William J. Alexanders
131 Mary Davidson Elms
132 Sarah Alexander, perhaps sister of William Julius Alexander
133 Mary Wilson, sister of Catherine Wilson Alexander
134 Sarah Elizabeth Blake, daughter of Margaret and James H. Blake
135 Margaret Davidson Blake, sister of Sarah
136 Mary Amanda Moore Springs, wife of Leroy Springs
137 Susan Nye Hutchison

compliment to have <u>her</u> appeal to my poor judgement for advice in any matter -- But in this case deeming it trivial I fear I replied in too light a manner, as she appeared mortified & troubled --When I visit again I will endeavor to attone for it in the most affectionate manner I am capable of. Just as I closed & sent it to the office[138] -- received a visit from my Sister Mrs Caldwell[139] & the Dr.[140] They remained until late in the afternoon.

[Thursday, March 30 and Friday, March 31, The Grove]
30- & 31st engaged mostly in gardening & having the grove put in order. I have been extremely dull & stupid for several days -- little inclination for reading or meditating on subjects which require much exercise of mind & writing any thing a task.

138 Office, post office located in Irwin & Elms Store
139 Harriet Davidson Caldwell, sister of Sarah
140 Dr. David Thomas Caldwell, husband of Harriet Davidson Caldwell

Editors' Annotation
April 1837

On April Fools Day Sarah expressed displeasure at the playfulness of the slaves. She believed that frivolity was a waste of time, and in addition she feared this activity might lead to unchristian lying and trickery. Sarah questioned cousin Mary McComb's faith, and lamented her own inability to ensure her cousin's salvation. This enduring concern of Sarah's occurs later in the month involving her Sabbath school students, her brother and her father.

Sarah was worried that the services of Reverend Leavenworth might not be retained, whether as schoolmaster or minister is unclear. Other sources depict Leavenworth as unpopular with some students, strict and unyielding, the very characteristics Sarah seemed to admire. In 1838 Leavenworth did leave Charlotte for Virginia where he founded a school for young women.

Sarah spent several days reading and meditating. She read *Horns Introduction* for religious edification and *Girard on Taste* for recreation. Neither book has been positively identified.

Her domestic duties included mending and varnishing the furniture "strange business for a lady." She took great pride in learning a new skill and saving her father the expense of hiring a cabinet maker.

Sarah confronted her brother about his ambivalent attitude toward salvation "as he expects soon to leave us." She did not say where William A.F. Davidson was going, but his plans must have changed, for he appears throughout the rest of the journal. William listened to her concerns, but not agreeing with them decided to consult their father who was still recovering from being thrown from his horse. Sarah expressed

that their father's "mind still born down by the incubus sinbliss" (a heavy spirit that induces nightmares), and he had a "presumptuous" interest in seeing into the future, which she considered forbidden. She attempted to convince them of their errant ways by reading aloud from Robert Pollak. The spiritual dissertation, *The Course of Time* by Pollak was a long, impassioned and forceful poem on human destiny and was quite popular at the time.

Sarah had a surprising and unexpected encounter with an uncle she had not spoken to for three or four years. She does not say which uncle, nor explain the nature of their rift. He may have been her father's stepbrother Samuel McComb, and the disagreeable conversation may have been about her father's financial troubles.

There is a confusion of dates in mid-April. She reported feeling "Indisposed - listless and stupid," and was obviously becoming ill. A few days later she was overcome by a malady that incapacitated her for several weeks. She did not resume her journal until mid-May.

April 1837

[Saturday, The Grove]

April 1ˢᵗ The negroes are amusing themselves by deceiving each other with playful jests --. An old custom -- but whence it had its origin I have never had curiosity to inquire -- but will the first opportunity -- It is certainly often cause of a species of lying -- & of course not to be countenanced by Christians. But I will not judge-- it may be innocent -- as I cannot approve it myself -- I will take no part in it -- It is to say the least -- a foolish custom. In the afternoon -- Mary M°Comb[141] and her brother Sam[142] surprised me with a visit -- Mary remained all night -- after too long indulging in light trivial talk -- I endeavored to prepare my mind for the coming Sabbath -- I questioned Mary in regard to her Souls salvation. As yet she has no abiding sense of her guilt in the sight of God & of course not much interested about the way of Salvation. Oh may I be more faithful in my masters cause -- & whence any opportunity is afforded of warning my unconverted friends of the danger of delay -- let me not by any levity of conversation or conduct contribute to the many hindering causes which tend to delay souls in seeking the Salvation of Christ.

[Sunday, The Village]

April 2ⁿᵈ Attended Sabbath School My class of little children were all in due time -- & more tractable than they have been -- I have too much considered what

141 Mary McComb, cousin of Sarah
142 Samuel McComb, cousin of Sarah

was pleasant to - myself in teaching in the Sabbath School -- but from this time I will endeavour to avoid all selfish considerations & willingly & cheerfully do what is considered by the superintendent for the general good of the School It is not by our own strength that we do any thing that is instrumental in leading souls to the Knowledge of God & the way of Salvation -- But through Christ who strengtheneth us we shall be able to do all things -- having given up myself to be guided --directed & disposed of agreeable to His holy will -- I will now endeavour by His aid - to be more faithful -- diligent & obedient doing with all my might whatsoever my hands findeth to do --- & leave it in His hands - for if the work engaged in is done through the influence of the Holy Spirit upon our hearts inducing us to action It is not our's but His work -- & He will perfect it--After Sabbath School walked home with Mary[143] & M^c Elms[144] -- I remained until the bell summon'd us to preaching -- M^c L[145] as usual enlisted the attention of his hearers - by his peculiarly interesting style -- The text today was "acquaint thyself with God & be at peace"[146] -- & the sermon was replete with interesting matter & instruction. I do most earnestly hope our citizens will exert themselves to retain his services -- He is to me both Pastor & friend -- & in both characters <u>much</u> do I love him: May the preaching of the Word by him be blessed & he made the happy instrument in the hands of God in winning Souls unto Christ. After preaching returned with my sister M^{rs} Blake[147]-- Dinner over we walked in the garden & when we returned found my Friend J. J. B.[148] & spending the afternoon in his society most pleasantly & also profitably returned home & when I had dressed Pa leg &c &c -- instructed the young servants in the commandments of God -- & His works --- their magnitude - beauty – variety & utility -- comparing them with the works of men found them totally ignorant on this subject. & with some difficulty enabled them to distinguish the works of nature from the works of art.

[Monday, The Grove]
 April 3^d Commenced reading Horns Introduction

143 Mary Davidson Elms, cousin of Sarah
144 William W. Elms
145 The Reverend Abner Johnson Leavenworth, minister of the Presbyterian Church at Charlotte
146 Job 22:21
147 Margaret Blake, sister of Sarah
148 John J. Blackwood, friend of Sarah

The Private Journal of Sarah F. Davidson, 1837

[Tuesday and Wednesday, The Grove]
Ap<u>l</u> 4<u>th</u> & 5<u>th</u> Enjoyed the priviledge of devoting my time exclusively to reading -- & meditation

[Thursday, The Grove]
Thursday -- 6<u>th</u> Engaged in domestic duties cleansing the house -- mending & varnishing the furniture -- Strange business for a lady -- I am thankful that my curiosity leads me to observe all that comes my way -- & endeavor to obtain <u>some</u> knowledge that may be not only interesting to me but useful to others. By this I save my Father the expense of applying to a cabinet maker & have also obtained for myself a practical knowledge in varnishing -- the experience of which will enable me -- when it is again required -- to do it better and with less labour.

[Friday and Saturday, The Grove]
April 7 & 8 Reading - Horms Introduction -& searching the references -- As recreation read Girard on Taste -- & practiced Musick.

[Sunday, The Village]
9<u>th</u> Attended Sabbath School -- & Preaching --May I ever duly appreciate these blessed priviledges whilst I am engaged in instructing may I also receive instruction -- & when I hear the gospel truths proclaimed -- let me not Oh Lord be a hearer only -- but a doer of Thy word with [illegible] to Thy glory and the praise be thine who alone can work in us the power & will to do. After meeting went home with Cousin Mary[149] & M<u>r</u> Elms[150] I dined with them. As the Teacher's meeting was appointed at M<u>rs</u> Blake's soon after dinner Mary & M<u>r</u> Elms accompanied me to her house. M<u>r</u> Elms left & did not return -- I fear he is not so warmly interested in this blessed cause as he ought to be. Oh Lord impress each one engaged as a Teacher of a Sabbath School of the great & high priviledge they enjoy of being cooperaters not only of Gods Ministering Servants but of God The Father -- God the Son & God the Spirit in leading souls -- precious immortal souls from the way of Eternal death into the way of eternal life. How transendingly great is the honored priviledge granted -- Oh may we all have our hearts sensibly affected & feeling the high responsibility of the station we occupy -- diligently and faithfully use all the means & helps with

149 Mary Davidson Elms
150 William W. Elms

ardent prayer and supplication that they may be blessed with power and wisdom from above to aid us in the right discharge of our duty. Oh Lord encourage our feeble efforts to serve thee with Thy prescience Thy immediate prescience - and Oh may the bands of youth who assemble in Thy holy sanctuary to receive instruction - be

> *"harken'd by Thy voice of heavenly truth*
> *few yield to Christ their youthful prime*
> *with all this talent and their time."*

My brother[151] and little nephew[152] came home with me - After Tea I call'd my brother into my Chamber & engaged with him in serious conversation - As he expects soon to leave us -- I was anxious to know the state of his mind - Although it is dark and obscure and much confused I rejoice that he is not what may be termed a hardened sinner - . He feels the importance and majesty of religion - but thinks he must wait until God by His Spirit constrains him to seek the Salvation of his soul - He talked much on this subject he finally appealed to Pa for his opinion - But his mind still born down by the incubus sinbliss - and too much indulging the presumptuous curiosity of man by which he would peer beneath he veil that God has infinite wisdom and may drawn between us and futurity - the present time is lost by vain and fruitless speculations. - I Endeavoured to arouse him by reading aloud some of Pollock[153] glowing descriptions and definitions - of Gods decrees His love to man - the glory and happenings of the redeemed - the everlasting poor & torment of the damned - after he returned to his bed - took my bible in which every line is

> *marked with the seal of high divinity.*
> *on every leaf bedewed with drops of love*
> *Divine, and with eternal heraldry*
> *And signature of God Almighty stamp*
> *From first to last - this ray of light.*
> *This lamp from off the everlasting throne*
> *I prayed would solemn silent prayer might*
> *beam upon his soul - & with its holy sacred*

151 William Frew Davidson
152 Probably Joseph Blake, son of Margaret and James H. Blake
153 Robert Pollok (1798–1827), author of "This Was the Course of Time," 1827, an elaborate poem in blank verse on human destiny modeled after Milton. It was widely read and highly popular among well-educated society.

The Private Journal of Sarah F. Davidson, 1837

light disburse the darkness from his mind
and be made unto him the power of Salvation.
I read - and without comment in silence left him to commune with God.

[Monday, April 10, The Grove]
10th Domestic duties - engaged me all day - at night too much fatigue to assemble my nights school for the young servants -- but permitted them to recite to me at my bedside.

[Tuesday, April 11]
11- Rode into the village to purchase my brothers[154] clothing for his journey. - Made some visits and as walking down the street met my uncle[155] with whom I had not exchanged words in three or 4 years - He spoke - Oh how rejoiced I felt - I can not express my feeling on this subject - were I to write all I have felt - this volume would not contain half - & they are not easily condensed - I have endevoured and trust a great measure succeeded in keeping mind free from unchristian complaints - & invictions - one thing I know that I entertained no enmity towards him -- & if circumstances had anyway required any service at my hands I would cheerfully and readily rendered it. I hastened home soon after this meeting as I understood a company of ladies & gentlemen were riding and I would be at The Grove - The excitement provided by the above circumstance with a crowd of painful recollections - & the fretfulness of my horse caused headache and I was compell'd to ride slowly - I met the company returning from The Grove -. I endevoured to prevail on them to turn with me - but saying they would soon be out again - chattered a few minutes & rode on.-------------------

[Some confusion of date, probably between April 12 and 16]
[Tuesday, The Grove]
11th Indisposed - listless & stupid all the morning - In the afternoon walked out to see an old sick negroe - & then to another who is I believe an humble & faithful disciple of the Lord Jesus - Whilst I set with her listening to her sing - One of the servants told me there was a carriage had arrived at The Grove - I was looking

154 William Frew Davidson
155 Unidentified uncle

for my Lincolnton Friends Sarah[156] - Ada[157] & Harriet[158] - & concluded it was of course them - I was disappointed in my conclusion but agreeably surprised to find M.[r] & M.[rs]. Leavenworth[159] Miss Peabody[160] & little Fredrick[161] also Miss Page.[162] How reviving is an unexpected visit from those we love. All my languor & indisposition were forgotten - The only regret I felt was at the shortness of their visit -but they promised to come back *soon* and make a longer visit. –

[Wednesday, April 12, The Grove]

12th- My pleasures & enjoyments increase and so full I fear I may forget myself in the source of these enjoyments -- & thereby vanity & self love elude the vigilance of my guard - I thank The heavenly Father that Thou hast by Thy good Spirit watched over me thus far - Oh still be Thou my guide & director - Leave me not one moment alone lest I wander and rush into difficulties and dangers -- that beset one on every side. Received unexpectedly a visit from my friend Ivor[163] - As usual I enjoyed his society much more than I express. –

156 Sarah Williamson of Lincolnton, North Carolina
157 Adeline Ramsour of Lincolnton, North Carolina
158 Probably Harriet Ramsour of Lincolnton, North Carolina
159 The Reverend Abner Johnson Leavenworth
160 Mary Ann Peabody, sister-in-law of the Reverend Abner Johnson Leavenworth
161 Fredrick P. Leavenworth, oldest son of the Reverend Abner Johnson Leavenworth
162 Miss Page, unknown
163 Ivor, John J. Blackwood

Editors' Annotation
May 1837

Sarah began writing again nearly a month after the previous entry. She opened the month with a long discourse summarizing the events of the intervening weeks. When her Lincolnton friends arrived, about a week after they were expected, Sarah was in a slave cabin with Clara reading from John Bunyan's *The Pilgrim's Progress*. The passage she was reading told of the journey of Christiana, wife of Christian, the pilgrim. Christiana and her children were accompanied by an allegorical guide and companion named Mercy. *The Pilgrim's Progress* was very popular, a nearly essential adjunct to the Bible in religious education.

Sarah's social activities with her Lincolnton visitors and others completely distracted her from her journal. She recounted an awkward evening at the home of her estranged uncle, but again does not reveal the reason for the rift, although she mentions that "persons present" had been the innocent cause of it. Her Lincolnton friends, whose stay she described as regrettably brief, must have visited less than a week.

The Davidson's slave children attended church in town. Sarah vowed to reinforce their lessons when they returned to The Grove. It is unclear how many she taught; about one-third of Mr. Davidson's eighty slaves were probably children. She told them of the privileges they enjoyed in having religious instruction, an interesting concept juxtaposed to slavery.

Next Sarah described the onset and course of a serious illness. She was under the care of Dr. Harris for twelve days or more. Several pages recount her experience replete with religious doubt and fantastic hallucinations, including "vivid flashes or corruscation [glitter or sparkle]

of light." She attributed these illusions, which she interpreted as religious visions, to medicine, copious bleeding or the illness itself. An opiate of Laudanum and bleeding were common in medical practice at the time. This long entry may have taken several days to write; the next entry is dated May 19.

The Friday before Holy Communion was observed by fasting, and generally honoring proscriptions normally reserved for the Sabbath. Sarah decided to fast, but was inadvertently drawn into an awkward situation, which she considered compromising, when her sister Margaret Blake asked Sarah to make a purchase for her. Sarah began the transaction then hesitated, but Margaret prevailed. Apparently doing business on a fasting day was forbidden in Sarah's eyes, but not in Margaret's. Sarah concluded she had benefited from the sin, as she had learned an important lesson.

Humphrey Bissell was a wealthy mine owner and a highly trained mining engineer, and with whom she enjoyed intellectual conversation, especially on the topic of geology.

An intriguing comment made in a Sunday entry concerned a successful teachers' meeting. If her journal had been "intended for other's perusal," she wrote, she would have recorded "interesting facts relative to the lesson," in other words, she might have used this journal as instrument to spread God's word.

Mary Graham Morrison was the wife of the Reverend Robert Hall Morrison who had become the first president of Davidson College when it opened its doors to students in March. Mrs. Morrison had given birth to her sixth child two months before, and was preparing to join her husband who was already in Davidson. Sarah rejoiced that Mrs. Morrison was a new "sister in Christ." One wonders why a woman who had been married to a prominent minister for thirteen years would be considered in "her infancy in Christ." We assume Mrs. Morrison had recently experienced a spiritual rebirth similar to Sarah's.

While visiting Catherine's home, catty-cornered across the street from the Baptist Church, Sarah was irritated by the noisiness of the church bell "within a rod of us." A rod, or sixteen and a half feet, was only a small exaggeration. She was bothered even more by the frivolity of the company.

Sarah spent the last few days in May shopping, visiting and generally engaging in her normal life. The terrible illness of the month before had completely left her.

May 1837

[Saturday, The Grove]

May 13th Days and weeks have roll'd into the vortex of time -- time passed and gone forever - since the record of the above notes - and the events producing this chasm in my journal can now be only briefly sketched as a connecting link by which future incidents may be attached to those accorded. My friends from Lincolnton on the 17th of April unexpectedly arrived - I was at the cabin of our old servant Clara[164] & had been reading a portion of Bunyans Allogory of Christiana,[165] her children, & Mercy[166] & was engaged with her in singing hymns of praise – when their arrival was announced -- I hastened to the house and met them with cordial greeting - and then dispatched a messenger to let our Friends who had been anxiously been expecting them, know they were at The Grove The reception & returning of visits occupied so much time. I laid my journal aside intending that memory should supply my pen afterwards with all to be transcribed. There was but one event that occurred that I shall now notice - Which was my accompan[ying] them to a dinner party at the house of my Uncle[167] - before I could decide how to act on this trying occasion my mind was in a most distressing frame - a tumult of thoughts, feelings and contending emotions agitated me --and when finally I

164 Clara, slave of William Davidson
165 John Bunyan, *Pilgrim's Progress (Second Part)*, 1684
166 Mercy, Christiana's allegorical guide/companion in *Pilgrim's Progress*
167 Unidentified uncle

consented - and found myself actually in the house to which I have been as a stranger for three or four years - & the persons present who had been the innocent cause of this estrangement I forbear to say what I felt - Indeed I feel that I am inadequate to the task even were it necessary my feelings on the occasion should be disclosed - & endeavoured to appear cheerful - but my countenance proved to be a faithful index of what was passing within - & I was frequently asked why I was so silent —what was the matter - These questions would arouse me for a while - but I soon relapsed & finding myself unable to converse freely - & act the part. I could not feel - I retired to a private room until it was time for us to take leave. - My young friends of L.[168] – with my cousin M. McComb[169] - & Miss Irwin[170] came home with me --- also My Brother[171] - Cousin Matthew McComb[172] Mr. Williamson[173] & Dr. T. Harris[174] - .

Next morning they left - We regretted their stay was so short. As there was a constant succession of visits & visiting I had but little of their individual society & when thus favored I indulge too much in unprofitable talk - which is one of my besetting sins And as I am now aware of it - I do earnestly hope I may by constant watching aided by the grace of God be soon delivered - Oh Lord purify & sanctify my heart -- & fill it with holy desires affections -- for out of the abundance of the heart the mouth speaketh - then shall my conversation be ever such as becometh a disciple of The Lord Jesus. On Sabbath after my Friends left - attended Sabbath School On This day Our good Pastor[175] had previously appointed to preach to the children - The day was unfavourable - cold misty rain - yet as there was a full attendance at Sabbath School - - Our Superintendent - with the teachers concluded to keep the scholars at the Church and apprize M^r. L - which was done - The sermon was well adapted to their capacities - even so the youngest might understand - from all & could learn - Children, Parents - & the congregation - were highly pleased & grateful- I was particularly pleased on leaving the Church to learn that nearly all the young servants

168 Lincolnton, North Carolina
169 Mary McComb
170 Mary Ann Irwin, daughter of John Irwin
171 William F. Davidson, brother of Sarah
172 Matthew McComb, cousin of Sarah and brother of Mary McComb
173 John Williamson, father of Sarah Williamson
174 Dr. Thomas J. Harris
175 The Reverend Abner Johnson Leavenworth

The Private Journal of Sarah F. Davidson, 1837

to whom I had been giving instruction were present & immediately resolved in my mind to assemble them so soon as I returned home - and endeavour to impress their minds with the things they had heard - the priviledges they enjoyed - & to prevail on them to attend constantly - not from compulsion.- but with gratitude for the priviledge and desire to be perfected. I was prevented carrying this resolution into effect in a way most unexpected and unlooked for. I had not felt well for some days - not sick - but a heaviness and lassitude which I thought the effects of a slight cold.- I ordered the carriage earlier than I usually do on Sabbath evening - because I was restless & uneasy - I felt chilly - yet attributed it to the dampness of the weather - and stood some time by the fire to get warm before I left - but still feeling cold remarked to my sister I felt like taking a chill bid her good evening got into the carriage & drawing my cloak around me directed Lawson[176] to drive fast as I felt very cold - When arrived at home found Pa seated by a cheerful fire - I took a seat immediately in front of it - & endeavoured to think it was only the effect of the weather - Pa was in a talkative mood - I proposed some scripture question - My voice trembled & I then mentioned to him I was apprehensive & I had a chill - I was soon compelled to lie down - the chill increased & was exceeded by high fever & violent pain in all my limbs -- the pain in my head was excessive ----& became so violent Dr Harris[177] was sent for ---I was under his care for the space of 12 days or more and suffered much --- I felt submissive in the hands of Him who thus chastened me for my good and my mind was busily engage to discern the cause--This I know – that as a Father pitieth his children so the Lord pity those who fear Him --- That He does not willingly afflict --- Our natural Parents in love corrects such errors as come to their knowledge – & Shall not Our Heavenly Father who knoweth the intents and purposes of our hearts – correct and save us from eternal ruin - "For whom the Lord loveth he chasteneth and scourgeth every son whom he receiveth." If then I am owned as a child and my Heavenly Father doth with the rod of correction turns me from my errors and leads me thereby in the path of obedience – pain and righteousness – welcome every affliction & every degree of suffering endured in this body of flesh to my souls eternal happiness & blissful rest I have reason to believe (at least hope)

176 Lawson, carriage driver and slave of William Davidson
177 Dr. Thomas J. Harris

that the meditat[ion] of my sick bed — the conversation of my beloved friend & Pastor[178] – and the course of reading during my convalescence – has been profitable to me – And Oh My all indulgent --- gracious and compassionate Father and Benefactor – praise and thanksgiving to thy Holy Name that my health and strength are nearly restored – help me to engage more faith--fully and zealously in Thy service – Yet humbly ---constantly feeling my own weakness – may I ever seek - and receive strength from Thee who Giveth grace for every time of need. And now when I again mingle in Society grant I pray Thee the influence of Thy Holy Spirit that I may at all times & in all places feel think and act as a child of God. — Let nothing have dominion over me in opposition to the suggestions of conscience and the principles of religion. And all the praise ever be ascribed unto the Father, Son and ever blessed Spirit. Amen. Thus was a peculiar effect produced on my optical nerves during my illness – which the D_r said was owing to the pressure on the brain. I could not bear the light for several days and my chamber was kept dark as possible – On one occasion the window was suddenly opened and so affected my eyes that I could not close them until late at night – and then the bright flashes of light which appeared was so intensely painful I was compell'd to open my eyes every few minutes to obtain relief from the dazzlingly brilliant objects – constantly passing before me — something in the manner of a succession of panaramic scenes in high perspective first – vivid flashes or corruscation of light – this light which was of a colour and brilliancy I can not describe this assumed an innumerable variety of forms – grotto cascades – planets swirling through infinite space with suns, moons, Stars, &c -- figures of intelligent creatures Sometimes only eyes being visible - the eye being pleasant but enclosed in a setting too dazzling to look long upon but the most singularly bright & strange appearance was a view of the Heavenly Host --- This I will not attempt to describe I looked until the inexpressible Brilliancy produced such violent pain I had to open my eyes for relief — & what is also strangely singular – that being under the influence of medicine --- debilitated by copious bleeding – and suffering extreme pain – as these scenes passed in review — my immagination was in active appreciation ---- And could I this have committed to paper what was passing in my mind - it would appear like magic – I distinctly recollect being surprised at the elevated flights of fancy – and again at the solemn and sublime thoughts presented to my mind and resolved so soon as I was able to commit them to the pages of my Journal -- But when the fever abated and the determination of blood to the head was diverted to its propper channels – The

178 The Reverend Abner Johnson Leavenworth

The Private Journal of Sarah F. Davidson, 1837

bright ideas & brilliant scenes vanished only leaving a faint impression on memories page of [scratched out] of the most striking scenes – but the sensations produced by them left no trace by which they might be recall'd

[Friday, The Village]
May 19th Friday before the Sacrament is administered tis generally observed in this section of country as a day of fasting - prayer and attending worship in the house consecrated to Jehovah – This morning I arose with the desire and intention of observing it in the usual manner of Christians – Although it had not been appointed – I left home in a calm & comfortable frame. I did not tell any one that I intended observing fast day - & I saw no one acting differently – but the usual business & vocations in full operation – And now was my weakness & proness to evil made manifest & the importance of the injunction — "watch & pray lest ye enter into temptation"[179] brought forcibly to my mind --. Mrs B[180]- represented an opportunity I had of making and advantageous purchase of an article that she desired in return for one of equal value I was to receive from her & desired me to send for it – Without reflection I did so – nor did I recollect myself until I had partly stipulated for the desired article. I immediately confessed what I had done & purposed to delay the purchase until another day – but was overuled – I did not know the course I ought to pursue – I found no opportunity of seeking direction from the fount & source of all wisdom. I trust that I may & have been benefitted by my error — Being humbled & made truly sensible of my inability to do any thing of myself – I enabled to cast myself entirely as a weak & helpless, sinful – depraved child on the mercy & compassion of my Heavenly Father against whom are my transgressions – I implore His aid divine – that I may receive grace & Spiritual strength to resist every temptation – & by His guiding power led in the way of righteousness and peace Attended preaching in the morning – afternoon & night – Spent the night at Dr Green Caldwells with my cousin M- McComb.[181] Had some serious conversation with her – but found no resting place for a hope that the great priviledges granted of hearing the way of salvation proclaimed (by the ministers of the only true living God) to lost & ruined sinners who are blindly going the way of eternal destruction – has as yet aroused her to make the enquiry – Where am I ?

179 Matthew 26:41
180 Margaret Davidson Blake, sister of Sarah
181 Mary McComb, cousin of Sarah

[Saturday, May 20, The Village]

20th Visited my friend Catherine[182] – who is much indisposed from cold settled in her jaw & ear.— & from there repaired again to the Church. The services commenced with a prayer meeting – preaching at the usual hours – good attendance & we trust the preached word has (been) blessed to many souls – although to the eye of man it is not yet manifest. After the evening sermon returned home. My little niece Margt M- Blake[183] came with me -- & my Brother[184] & Miss M A Irwin[185] rode a part of the way & walked back to the Village.

[Sunday, May 21, The Village]

21st The holy Sabbath --- Many shall assemble today around the place from whence God's truths shall be proclaimed – And how many shall be made wise unto Salvation – Eternity alone will reveal.

-- Oh how unworthy am I of the many rich blessings I dayly receive. The two days that are passed I enjoyed the priveledge of unrestrained attendance on divine worship – My soul nourished & strengthened by Gods holy word & the communications of His Spirit. & today Oh how richly has he blessed (me) My soul is full to overflowing –Oh how inadequate I feel [illegible] to express my feelings – Accompanied by my dear Father[186] I again enjoyed the means of Grace – But I will not -- indeed I cannot attempt writing out my feelings on this occasion – I only can say adored by my Lord & my God & unto Him be all praise - Unto Thee I dedicate myself – it is all that I can do – accept & own me as Thy own & guide direct & dispose of me as may seem good unto Thee.

[Wednesday, May 24, The Grove]

24th Received a visit from Mr- H. Bissel[187] – when he is in a pleasant mood no one can be more agreeable & interesting – His conversation was this evening cheerful -- & particularly interesting to me as he said much on the subject of Geology – in

182 Catherine Wilson Alexander
183 Margaret M. Blake, daughter of Margaret and James H. Blake
184 William Frew Davidson
185 Mary Ann Irwin, daughter of John Irwin
186 William Davidson

The Private Journal of Sarah F. Davidson, 1837

which I take great delight – I never have mentioned any subject to him that I was not impressed – by his clear & discriminating remarks – Oh that his heart was sanctified by divine grace -- & his talents consecrated to the God from whence he received them.

[May]
28th 29th & 30th –

[Sunday, May 28, The Village]
28th Attended Sabbath School – in the morning & as there was no preaching in the Presbyterian church – M[r]. L[188] being absent – I declined going elsewhere as I had previously ascertained I could be more profitably employed at home – Soon after I returned from S School — M[r] Elms[189] call'd & also my friend M[r] B[190]
-- & spent the forenoon with us. Our Teacher's meeting at 3 o Clock although few attended was quite interesting -- & were this Journal intended for other's perusal I might insert many interesting facts relative to the lesson which was on this the occasion the subject of our investigation – The Teacher's meeting I find profitable in many ways – but particular as a excitement to the enquiring mind – causing a more critical examination – by the contact of mind with mind -- At night attended the Methodist Church & heard M[r] Owens[191] of the Baptist institution

[Monday, May 29, The Village]
29th Visited my Friend Catherine[192] -- She was much indisposed -- But we had some pleasant hours together unrestrained by the presence of indifferent persons - Our communications were those of friends under similar circumstances. After dinner call'd on M[rs] Morrison[193] - I much regret that she leaves at the present time – so interesting to her friends & important to herself for we have but just hailed her as a sister in Christ - when we are call'd to say farewell & give the parting kiss. But trust she will be spared to return & become a bright & shining light amongst

188 The Reverend Abner Johnson Leavenworth
189 William W. Elms
190 John J. Blackwood
191 Mr. Owens, Baptist minister
192 Catherine Wilson Alexander
193 Probably Mrs. Mary Graham Morrison, wife of Robert Hall Morrison

us - May she also be blessed & now in the days of her infancy in Christ - cherished & nurtured by the Holy Spirit & grow rapidly - manifesting to all around that she is indeed the child of God & may many listen & hearken to her voice & seek reconciliation with God our Father through our Lord and Savior Jesus Christ I then returned to Catherine's[194] & found my sister Mrs Blake[195] & Miss M. Lowrie[196] also Mrs. Alexander[197] & her sister Margt.[198] joined us -- After Tea Gentlemen came in Catherine was too much indisposed to be with us - I of course did not so much enjoy the company as I might have done had she been present. The Church bell at the Baptist Church[199] within a rod of us - rang long & loud but none appeared to hearken to the note - But feeling that there was much levity of conversation to be endured - Mrs D A[200] & myself left the company and - (alone) repaired to the Church - when we returned we found the company in high Glee - I immediately went up to Catherine's chamber & after a short interview returned to Mr Blake[201]

[Tuesday, May 30, The Village]
30th Mary McComb[202] Mrs Blake & myself made some calls – shop'd a little - & as it rained very hard -- Mary remained with me all day -- After Tea we call'd to see M. A. Irwin[203] & remained until quite late.

[Wednesday, May 31, The Village]
31st Pa had not yet returned -- & as I expected some friends -- I was impatient to return to The Grove -- They did not send for me & I borrow'd a horse - & was really

194 Catherine Wilson Alexander
195 Margaret Davidson Blake
196 Margaret Lowrie
197 Anabella Alexander, wife of Dan Alexander village merchant
198 Margaret Wilson, sister of Catherine Alexander
199 Baptist church located on the corner of present day 3rd Street and College Street
200 Mrs. Dan Alexander
201 James H. Blake, Sarah's brother-in-law
202 Mary McComb
203 Mary Ann Irwin, daughter of John Irwin

The Private Journal of Sarah F. Davidson, 1837

rejoiced when I felt the refreshing breeze my [illegible] Grove -- -- In the afternoon Mary McComb & M[c] Blackwood[204] rode out - Pa returned -- Then came Catherine & her Babe - - D[r] Wallace[205] & M[c] Johnston[206] - Catherine did not remain long - & after a stroll in the Garden D[r] W[207] & M[c] J left. Mary M[c]-B[208] & myself - engaged in Musick & conversation until supper was ready - after Tea we rambled through the Grove and up the lane until the muddy walk caused our return -- -- M[c] B staid until bed time & left with a promise to return for Mary the next evening - It rained - he did not come but sent a polite handsomely written note -- &c –

204 John J. Blackwood
205 Dr. Rufus A. Wallace

Editors' Annotation
June 1837

For most of June Sarah was occupied in social activity, both at The Grove and in the village. Many visits and visitors are noted, and Sarah commented how important they were to her. She also expressed her love for nature and natural science in the description of a brilliant sunset during a ride to the village.

She again worried about the salvation of souls, particularly that of her friend Mary, the young ladies of her Sabbath school and the slave children. She feared her own shortcomings might be the cause of their lack of convictions. She frequently visited Dr. Pinckney Caldwell, brother-in-law of her friend Catherine, who was ill with cholera and appeared near death. She offered comfort and was concerned that he might not be ready to meet his maker, but the good doctor recovered.

Miss Dyott, who is mentioned frequently, was probably a student at Reverend Leavenworth's female school and a boarder with Sarah's close friend Catherine Alexander. She referred to Mrs. Dyott (Miss Dyott's mother) as a "stranger in our village."

One Sunday, Sarah attended the Baptist Church, as it had become the custom for other churches to suspend services when one among them celebrated Communion. An unidentified Dr. L. was the preacher. Sarah was greatly offended by his sermon containing "rude unchristian assertions." She found him vulgar, irreverent, an "offence to the unconverted," and a "trial to believers." Literacy was highly valued by Presbyterians to protect themselves from such misguided ministers. Reverend Leavenworth sat beneath the pulpit and listened to the man calmly and patiently. Sarah wished she had such a Christian spirit.

A Life in Antebellum Charlotte

Mr. McDowal and the students she encountered at her sister Harriet's home were boarders. The Caldwells lived near Sugar Creek Presbyterian Church and frequently took in students and tutors of the church's academy.

Sarah was embarrassed at having made a "hasty toilet" when unexpected visitors appeared. She had put on a work dress without corsets, and felt quite ill at ease. On another occasion she and her friend Mary "undressed and lay down on the bed." Undoubtedly they removed only their outer gowns, and were still clad in copious layers of undergarments.

Her attitude toward the slaves was typical of the time. She matter-of-factly recorded giving the slaves instructions in the kitchen, and having them gather vegetables. She worried that the young servants had retained the incidents of their Bible lessons, but not absorbed their meaning. On talking to slaves in the garden she wrote: "the old appear to regard us as their children and manifest much solicitate for our welfare. May we in return do all we can to render them happy and comfortable."

Sarah expressed great affection for Reverend Leavenworth and Mr. Blackwood. There is no indication that her admiration was more than platonic. They were guides in her spiritual journey, and encouraged her to take on teaching young ladies, rather than children, in Sabbath school. Sarah was intimidated by the task. The young ladies would soon become wives and mothers, responsible for the religious convictions of their husbands and children and, therefore, the entire community.

Colonel Wheeler and Mr. Strange were superintendent and clerk of the newly established branch of the U.S. Mint. The building contained Wheeler's living quarters as well as public rooms open to the community, which is probably where the paintings were hung that made such a poor impression on Sarah. Colonel Wheeler later married Ellen Sully, daughter of Philadelphia artist Thomas Sully. Ellen was also an accomplished artist. It is interesting that one hundred years later the mint building became an art museum and now owns of some of Thomas Sully's work.

June 1837

[Friday, The Grove]

June 2ⁿᵈ - Mary[209] & myself - read sewed - had musick. - William[210] was out in the morning After dinner - We took the Lyre & being seated in The Grove - - sang until we tired - & stroll'd into the Garden - Catherines[211] carriage passed & we returned to the house. She had Sarah[212] - Mary[213] - & William[214] with her - soon after she arrived Mᶜ B[215] drove up to the door in a Buggy for Mary[216]- They all remained until after -- & Catherine insisting very much for me to return with her I finally consented & we all left at the same time. -- Our ride to the Village was delightful -- The road smooth -- the horses lively & moving with spirit -- The setting sun shedding a soft & mellow yet glowing light -- The breeze gently wafting the odour of the various flowering plants which is particularly sweet & pleasant at sunset & the twilight hour. As we emerged from the woods -- & ascended the hill

209 Mary McComb, cousin of Sarah
210 William Davidson, Sarah's brother
211 Catherine Wilson Alexander, friend of Sarah
212 Sarah Alexander, sister of William Julius Alexander
213 Either Mary Wilson, sister of Catherine W. Alexander, or Mary Alexander, Catherine's daughter
214 William F. Davidson, brother of Sarah
215 John J. Blackwood
216 Mary McComb

beyond the creek our attention was attracted by the beautiful tints on the western horizon We gazed in silent admiration until our view was interrupted -- I will not attempt a description -- for who can impress the vividness -- softness -- & blending of the various shades - on the eye of imagination by the --pencil --brush or magic of words The painter may produce a picture worthy of his art -- & The Poet excite to enthusiasm by his brilliantly glowing descriptions. – But let the <u>eye</u> once drink from the stream of <u>reality</u> -- & naught -- but nature's self can satisfy -- Col^a Wheeler[217] & M^c Osborn[218] - call'd at Catherine's after we returned & with Miss Dyott[219] -- we formed a socially formal company – [words crossed out]

[Saturday, June 3, The Grove]

3^d Catherine came home with me -- but as she look'd for our old friend M^{rs} Smartt[220] returned to the Village after an hour's stay. A long list of visits & visitors -- yet I have less to regret than I ever did before – even when less engaged - I know how much I have mourned such occasions when left to my own reflections -- hence now -- I invariably make it a subject of prayer - & I have in this instance not only sustained but trust benefited by the interview I have had with my friends & acquaintances. - All the time since our communion -- & now also -- I have felt the spirit of adoption whereby we cry Abba father -- Oh Praise glory & thanksgiving. To my God for all His loving kindness & tender mercy

[Sunday, June 4, The Village]

4th Attended the Baptist Church – It is now generally understood & expected – when there is a communion season in any of the Churches the usual service in the other's is suspended for that day - On this occasion Our beloved Pastor[221] -- & as many of his people as could be accomadated with seats attended Oh - what shall I record of this day -- although the provocation was great I fear I did not act as a disciple of Christ in the house consicrated to the worship of God -- D^r L[222]-- was the preacher - had I known more of the man my indignation would not have been so great which I confess arose So

217 J. H. Wheeler, superintendent of the U.S. Mint at Charlotte
218 James Walker Osborne, lawyer
219 Student at the Female Academy
220 Unidentified
221 The Reverend Abner Johnson Leavenworth
222 Dr. L., unidentified Baptist preacher

contemtiously high I almost forgot I was in the Church and M̄ͨ L[223] sat immediately under the pulpit or rather at its base & listened calmly & patiently -- at the rude unchristian assertions – pronounced above him -- which he could with so much ease have refuted without shocking the feeling of the most fastidious. But I will say no more -- Let us all exercise a Christian spirit - & bear with the folly & vain pride of man - & guard against the indulgence of a criticising ear in hearing the Gospel - We have been blessed so highly blessed in our Pastor it requires watching & forbearance to be benefitted by inferior men -- much more the illitterate & must I say -- vulgar -- It is too true -- that the preaching of some is so low & irreverent -- as not only to be [illegible] of offense to the unconverted -- but the trial of patience with believers. Mary Elms[224] came home with me Sabbath evening & remained until tuesday morning

[Wednesday, June 7, The Grove]

7th Indisposed -- did not rise until after Breakfast -- In the afternoon felt better & in the evening accompanied by a servant rode to my sisters Mrs Caldwell's [225] -- she was visiting a sick neighbor -- The Dr[226] was at home & M̄ͨ McDowal[227] & his scholars had just got home from school & were amusing them-selves in the yard when I rode up -- I was formally introduced -- & after divesting myself of my riding dress &c &c -- chatted with Dr & M̄ͨ McD -- until supper was ready -- my sister being still absent -- I officiated at the head of her table -- & whilst there she arrived – she was somewhat surprised to see me -- & expressed her usual gratification - she had looked for me in the morning -- & concluded as I did not go then I had defer'd my visit for some other time. I have not visited her so often during the last six months as I wish'd -- My health is now improving & without making a promise I design visiting her quite often. After family worship -- we took some refreshment & retired -- enjoying that calm & quiet slumber which ever accompanies a heart at peace with its Maker -- & freed from bodily pain - But Oh how often am I guilty of ingratitude for these inestimable blessings -- by indulging in desires which He may in goodness & mercy withhold the gratification. Just praise unto Thee my God -- that notwithstanding these wanderings of my heart -- It yet turns to

223 The Reverend Abner Johnson Leavenworth
224 Mary Davidson Elms, cousin of Sarah
225 Harriet Elizabeth Davidson Caldwell, sister of Sarah
226 Dr. David Thomas Caldwell, husband of Harriet and brother-in-law of Sarah
227 Robert Irwin McDowell, teacher at the Sugar Creek Academy, boarding at the Caldwell home

A Life in Antebellum Charlotte

Thee for guidance & direction with desire to ruled by Thee in all things —

[Thursday, June 8, Caldwell Plantation]

8th Mary M^cComb[228] & my Brother[229] met me at the D^r[230] - & after amusing ourselves & enjoying the society of the D^r & my sister[231] they rode with me to The Grove --. Supper was ready - they alighted - Then after partaking with us a cup of hot coffee — muffins &c &c returned to the Village.

[Friday, June 9, The Grove]

9th Slept later than usual - and had to make a hasty toilet to be ready for breakfast. Walked to the garden to have vegetables gathered before the Suns heat impaired their flavor & freshness intending to arrange my dress better when I returned -- but before I had given my directions in the kitchen -- M^c- Osborn[232] & M^c Blackwood[233] rode out & were in the house before I was aware of their arrival - I was somewhat confused on account of my soiled dress & no corsets on -- but made no apology as they probably would not observe I was not as neat as usual unless I directed their attention to a close observation of me by an apology for appearing before I dressed. But I did not choose to forego so much of their society as to wait until I paid the usual attention to my personal appearance.

[Saturday, June 10, The Grove]

10th Late in the afternoon agreeably surprised (whilst sitting at the Pianno) on looking out of the window to see M^c Leavenworth & M^c Blackwood -- Oh how charming & gratifying to receive visits unexpectedly from those we regard & love as friends of congenial spirit & one in heart by faith in our Lord Jesus Christ — With them I am not temped to stray & wander ~~from~~ in the worlds vain & idle pleasures ---- Oh that all with whom I associate were of this same spirit -- subjects of the renewing grace of God --- avowed & faithful disciples of our Lord and Savior Jesus Christ. With Thee Oh heavenly Father is all power - from Thy eternal Throne issue the Laws by which the universe is

228 Mary McComb, cousin of Sarah
229 William Frew Davidson, brother of Sarah
230 Dr. David Thomas Caldwell, brother-in-law of Sarah
231 Harriet Elizabeth Davidson Caldwell, sister of Sarah
232 James Walker Osborn, attorney
233 John J. Blackwood

governed -- and Thy decrees are holy wise just & rightious decrees -- Unto Thee we bow in humble adoration of the infinite perfections of Thy Character. -- & impressed with a sense of our utter unworthiness in Thy sight in whose pure eyes the Heavens are unclean --- Yet in the Son of Thy love through whom we have access unto thy throne of Peace -- & in whose name we are priviledged & invited to make supplication & present the petitions of our hearts desires, with the blessed promise of being heard & answered -- in the exercise of faith in these blessed assurances we plead for the outpouring of Thy Holy Spirit upon all with whom we associate -- and upon all for whom it is our duty & priviledge to pray - especially those that are near & dear unto us as relatives -- friends & acquaintances. In the arms of faith we bear each one unto Thee -And as Thou when on Earth in Christ Jesus didst hearken unto the voice of supplication in behalf of afflicted friends -- rejecting <u>none</u> who came unto Thee -- Oh now listen & have compassion upon the sin sick souls we present for Thy healing power -- Create in them clean hearts & renew a right spirit within them -- purify & sanctify them from all uncleaness -- & make them meet to become the partakers of the inheritance of the saints of light. -- & unto Thee, Father, Son and ever blessed Spirit be all praise power & dominion. -- worlds without End.

[Sunday, June 11, The Village]

11th Attended Sabbath School -- & Church & after I returned home Examined the young servants on the scriptures -- from the 1st to the 10th chapter of Genesis -- I find they have retained most of what they have learned -- but fear there is only a recollection of incidents & names -- & that they do not retain the practical inferences -- that I have endeavoured to impress upon them. But I will pray & labour for their better instruction & may the blessing of God attend my feeble efforts in their behalf to the eternal salvation of their immortal souls.

[Monday, June 12, The Grove]

12th Mrs Blake[234] - -Mrs Harris[235] -- Mrs Jane Caldwell[236] & Mrs Mary Elms[237] accompanied by my brother[238] walked out to The Grove -- spent the day with me &

234 Margaret Davidson Blake, sister of Sarah
235 Elizabeth Locke Harris, wife of Dr. Thomas Harris
236 Jane McComb Caldwell, wife of Green W. Caldwell
237 Mary Davidson Elms, cousin of Sarah
238 William Frew Davidson

in the evening returned to the Village except M[rs]. B.[239] She remained until tuesday evening & I then accompanied her home. ---After Tea Mary[240] & Mary Ann[241] came to see me -- After the usual salutations, &c &c a walk was proposed -- Miss Lowrie[242] & Mary Ann's little sister[243] joined us -- we walked as far as D[r] Harris's[244] -- & as Mary left we went no farther -- & at the gate we met Col[n] Wheeler[245] who accompanied us home – Mary McComb[246] was at M[r] Blakes[247] -- & soon after she came Col[n] Wheeler again made his appearance & spent the evening with us.

[Wednesday, June 14, The Village]

14th M[rs] Blake[248] went out shopping -- & on our return found Mary McComb had call'd also M[r] Blackwood[249] -- -- Mary and myself call'd on Miss Gay[250] & Miss Lowrie[251] -- returned to M[r] B[s][252] and chatted &c &c-- Mary left exacting a promise to visit her in the evening. After dinner designed visiting M[r] Leavenworth[253] & family -- but was prevented by showers of rain but was agreeably entertained for three or 4 hours by friend Ivor[254] -- when it ceased raining I put on my overshoes & went to D[r] Harris's[255] remained until after tea & then agreeable to my promise to M. M[c]C[256]

239 Margaret Davidson Blake, sister of Sarah
240 Mary Davidson Elms, cousin of Sarah
241 Mary Ann Irwin, friend of Sarah
242 Either Margaret or Eliza Lowrie (sisters), daughters of Samuel Lowrie
243 Probably Octavia Elizabeth Irwin
244 Dr. Thomas Harris
245 John H. Wheeler, Superintendent of the U.S. Mint at Charlotte
246 Mary Davidson McComb, cousin of Sarah
247 James H. Blake, brother-in-law of Sarah
248 Margaret Davidson Blake, sister of Sarah
249 John J. Blackwood
250 Miss Gay, unidentified
251 Margaret or Elizabeth Lowrie
252 Mr. Blake, brother-in-law of Sarah
253 The Reverend Abner Johnson Leavenworth
254 John J. Blackwood
255 Dr. Thomas Harris
256 Mary McComb

The Private Journal of Sarah F. Davidson, 1837

left with another promise to return & spend the night if it did not rain Dr Harris accompanied me. Mary[257] was looking for me but was disappointed in not seeing Mr B[258] with me/ -- but peculiar circumstances prevented his accompanying me.

Aunt McComb[259] was also at Ivors -- After we had conversed a while Mary requested me to play the "Dying Christian[260]" or Vital Spark of heavenly spirit whilst sitting at the Pianno -- Dr C[261] & my brother[262] came in and changed the character of our musick and in the midst of a lively air -- Mr Strange[263] Mr Harris[264] and Mr Conner[265] entered -- they remained until 11 o clock -- Mary[266] & myself accompanied by Brother then went to Dr Harris's[267] -- Mary[268] was looking for me and spoke to us from the window -- we found the door left unlocked for us-- after giving M[269] an account of the manner we had spent the evening as an apology for the lateness of the hour-- retired to partake of the rest wisely ordered & so necessary to refresh us for the respective duties of each coming day. As we were returning the next morning met Cola Wheeler[270] & Mr Strange[271] - who insisted on our walking to the Mint to see some paintings he has just recd --- he would take no refusal - & we turned and complied with his request -- I recd no impression in this visit worthy to be remembered. Finding Lawson[272] had not come for me when I returned to my Sisters[273] - I call'd to see my friend Mrs Springs[274]

257 Mary McComb
258 John J. Blackwood
259 Alice Brandon McComb, Mary's mother
260 Alexander Pope (1688–1744), *The Dying Christian to his Soul*
261 Caldwell, probably P.C. Caldwell
262 William Frew Davidson, Sarah's brother
263 William F. Strange, Clerk of U.S. Mint at Charlotte
264 Probably Dr. Thomas Harris
265 Unidentified
266 Mary McComb
267 Dr. Thomas Harris
268 Mary Davidson Elms, whose home was very near Dr. Harris's
269 Mary Davidson Elms
270 Col. J. H. Wheeler, Superintendent of U.S. Mint at Charlotte
271 Mr. William F. Strange, clerk of U.S. Mint at Charlotte
272 Lawson, carriage driver and slave of William Davidson
273 Margaret Davidson Blake
274 Mary Amanda Moore Springs, wife of Leroy Springs

A Life in Antebellum Charlotte

- & from thence to M[c] Leavenworths[275] -- Whilst there Miss P[276] - again urged me to take charge of the Bible class principally composed of young Ladies -- This is the most responsible class in our Sabbath School -- among the females and when we reflect that it is from the Mother a child receives its first impressions -- and that those who are now the youthful subjects of Sabbath School instruction will probably in time have the responsible duties of wife & mother to discharge & by the influence of precept & example indelibly impress with good or evil -- well may I say it is the <u>most</u> responsible class in our School -- & feel myself inadequate rightly to discharge the duty of a faithful Teacher to them. M[rs] Alexander[277] now has charge of it & far from my heart is the wish to take it out of her hands -- But as M[r]. Leavenworth[278] M[r]. Blackwood[279] -- & the Teacher's appear to think I ought to take it. -- when she voluntarily resigns In the strength of my Redeemer I will do all Things required of me. For He is our strength -- & He has promised to give us grace and strength for every time of need -- & being not my own but His who purchased me with His blood -- I yield myself the willing, & submissive servant – to do His will -- & be guided directed & disposed of as may seem good unto Him. All the power of body and mind we posess we received from Him and He can increase it tenfold -- But it is not of the high & of the great -- but with the weak He showeth His strength -- Therefore let none that are Christs fear -- for when they feel weak then are they strong -- casting aside the impotency of self -- Christ is our resort -- & is by Christ we conquer -- & all the praise & glory be ascribed to Him unto whom alone praise & glory is due -- After I left M[c] L's[280] call'd at Catherines[281] -- Miss Dyott[282] & then returned home --

[Friday, June 16, The Grove]
 16th Depressed ------- restless --- no enjoyment.

[Saturday, June 17, The Grove]

275 The Reverend Abner Johnson Leavenworth, minister of Presbyterian Church of Charlotte

276 Mary Ann Peabody, sister-in-law of the Reverend Abner Johnson Leavenworth

277 Probably Jane Henderson Alexander, mother of William Julius Alexander

278 The Reverend Abner Johnson Leavenworth

279 John J. Blackwood

280 The Reverend Abner Johnson Leavenworth

281 Catherine Wilson Alexander, friend of Sarah

282 Unidentified

The Private Journal of Sarah F. Davidson, 1837

17th Walk --- little exertions to overcome the oppression of spirits that render all I do heavy & dull -- My exertions must be more active -- I must plead for help or I shall grow worse My Brother[283] spent the evening with us = after he left attended to my school.

[Probably Saturday, June 17, The Grove]

18th My Brother & M McComb[284] unexpected rode up. M. remained until after dinner -- we undressed and lay down on the bed -- W[285] had walked to the garden and when he returned opened the door to take leave for town -- I was sorry I had not waited until he left -- It is seldom he visits us -- and I felt that I ought to have exerted myself more to render his time pleasant. We had much talking but I fear not so profitable as it might have been. May I be a faithful friend to Mary & Oh Holy Father if it is not inconsistant with Thy holy will -- make me the instrument in Thy hands of doing good to her immortal Soul We rested some time -- I then gave her a musick lesson -- After Tea we walked -- & did not return until it was quite dark. Conversed with Pa -- played & sung some musick for him = & then retired -- before we went to sleep had some serious conversation with M[286] And I feel encouraged to be more zealous in the cause of her souls salvation.

[Probably Sunday, June 18]

19th Attended Sabbath School -- Mrs. A.[287] requested me to hear her class as she was not prepared on the lesson & she would attend to my class of little children -- I complied -- The young Ladies were are all deficient in their lesson & appeared to feel all the remarks I made unnecessary -- & irksome to listen to -- seeing the state of their minds I was brief as possible & left them -- shuttering and trembling at the thought of having charge of them. But in Thy hands Oh God are the hearts of the children of Men -- ever as clay in the hand of the Potter -- Thou canst mould them according to Thy will -- & make them anew in Christ Jesus. Mc Irwin[288] walked with me home & said much on the duty of the Teachers in regard to the pupils

283 William Frew Davidson
284 Mary McComb, cousin of Sarah
285 William Frew Davidson, brother of Sarah
286 Mary McComb, cousin of Sarah
287 Probably Jane Henderson Alexander, mother of William Julius Alexander
288 John Irwin

taking a part in singing the Hymn of praise preceeding prayer. I heartily concur with him -- And will endeavor to overcome all my fastidious notions if such they are about singing -- I know I have in part succeeded and with my Heavenly Fathers blessing = I will strive by frequent practice to attain a perfect command of my voice. Pride has done much in preventing me from Singing -- But the ardent desire I feel to join in singing Gods praise I trust will guide me in obtaining a victory over every obstacle & that I may soon be able at all times & in all places take an active part in this pleasing duty and blessed privilege. At 2 o clock attended Teachers' meeting at M^r. H. Williams's[289]-- We concluded to hold our meetings hereafter in the Church. After the meeting closed -- called to see D^r. P. C. Caldwell[290] who I found very sick. Accompanied by Aunt M^cComb[291] & M^{rs.} Smith[292] returned to M^{rs}. Blake's[293] -- She was not at home -- I gave Lawson[294] directions to get ready for going home -- & whilst waiting for the carriage M^r. Blackwood[295] call'd -- We had some interesting conversation on the subject of Mission Tract Society -- Sabbath School -- &c&c When the carriage was ready none of the family appearing I left -- & M^r. B.[296] rode with me to the fork of roads above the Spring. Our Conversation was much as usual -- He related an interesting interview he had in the morning after Sunday School with quite a small boy which induced reflections of the great duty Parents owe their children -- the dear pledges of their plighted love --- gifts from God --. and oh how mournfully distressing is the frequent evidence we see of the <u>utter</u> neglect of the most important duty they owe their offspring.-- I have two little immortal souls committed to my care by a dying Mother -- a servant[297] who attended on me for me two years previous to her death. May I be enabled by the grace of God to bring them up on the fear & admonition of the Lord. After Tea attended to the instruction of our young servants.

289 Henry B. Williams, merchant
290 Dr. Pinckney Coatsworth Caldwell
291 Alice Brandon McComb, wife of Samuel McComb
292 Unidentified
293 Margaret Davidson Blake, sister of Sarah
294 Lawson, carriage driver and slave of William Davidson
295 John J. Blackwood
296 John J. Blackwood
297 Amanda, slave of William Davidson

The Private Journal of Sarah F. Davidson, 1837

Monday [Probably Monday, June 19, The Grove]

20th Another week has commenced & may I find at its close if I am spared this long that My time has been profitably employed -- Renewed the dedication of myself to my God With ardent supplications for grace & spiritual strength live a more holy life -- to have my heart purified from all unholy thoughts & feelings & that <u>no desire</u> may be cherished that is inconsistent with His holy will to gratify -- for He knows what is best for me better than I can conceive for often the gratification of our desires results in unhappiness & sore trials & what we in our ignorance would earnestly plead to be delivered from -- bring joy & gladness These times have I found to day before the throne of grace & mercy -- & have felt in peculiar manner the spirit of prayer in ejaculations & breathings of my hearts desire in silent aspirations -- May it continue to increase until my soul may be burdened with strong & fervent desires & longings for the influence of the Spirit - not only in my own soul & those near & dear unto me - but may it with the Saviors love embrace the world & bear it in the arms of faith to Him who has power to save from eternal destruction --. & Oh grant eternal Father the Son of Rightousness may dispel the darkness that now rests upon the largest portion of our Earth. Oh have pity & compassion on our benighted brethren who are strangers to thy grace -- who know <u>Thee</u> not but in their ignorance bow down to wood -- stone & creeping things -- & reveal Thyself to them in the Son of Thy love After tea taught my classes -- & conversed with them on what they had been learning – with practical inferences -- & exhortations.

[Wednesday, June 21 and Thursday, June 22, The Grove]

21st & 22nd Another visit from my Brother[298] we walked to the Orchard & Garden & had some pleasant interviews with the servants. The old ones appear to regard us as their children & manifest much solicitude for our welfare - May we in return do all we can to Render them happy & comfortable -- by kindness and attention to their wants.

[Thursday, June 22, The Grove]

22nd Looked for some friends but disappointed wrote to my friend M. A. Caldwell[299] & rec'd one from my friend A. Ramsour[300] --

298 William Frew Davidson
299 Unidentified
300 Probably Adeline Ramsour

A Life in Antebellum Charlotte

[Friday, June 23, The Grove]

23rd My Brother came out before breakfast to accompany me to the Village -- he brought me a letter from my friend S. Williamson[301] -- She feels & mourns the cold state of Religion in L[302] — presses me to visit her -- &c &c After breakfast we rode on horseback to town – M[303] - was at Mr. B'[304] after freeing myself of my riding habilment -- and resting a while -- went shopping - -made some small purchases & returned -- I then call'd on Mrs. Dyott[305] (a Stranger in our Village) -- Catherine[306] & then to see Dr. P. C. Caldwell[307] who is at the threshold of the grave from a violent attack of Cholera Morbus. As there was much company -- I returned to Mr. Blakes with a promise to return in the afternoon. On my return Miss Watson[308] was there -- she dined with us -- & also accompanied me to the stores to procure some articles for my Lincolnton Friends. After dinner Mr. Blackwood[309] call'd & from what passed — I here enter my resolution never to banter him about Miss C[310] again. Call'd to see Mary McComb[311] & then returned to Catherines -- found Mrs. Dunlap[312] & Mrs. Taylor[313] there - - to spend the evening -- I left a while to visit Dr. P[314]--- ---- Tea was early. & the ladies left at twilight – Catherine & myself then had an social chat -- & again went to see Dr. P-- ---When we returned found Miss Dyott[315] sitting in the dining room alone -- We all engaged in conversation & enjoyed ourselves unrestrained -- about 10 o'clock to our astonishment the bell rang -- & in stepp'd Mr. Bissel[316] -- Catherine did not

301 Sarah A. Williamson of Lincolnton, North Carolina
302 Lincolnton, North Carolina
303 Mary Davidson Elms, cousin of Sarah
304 James H. Blake, brother-in-law of Sarah
305 Mother of Miss Dyott
306 Catherine Wilson Alexander, friend of Sarah
307 Dr. Pinckney Coatsworth Caldwell
308 Unidentified
309 John J. Blackwood
310 Unidentified
311 Mary McComb, cousin of Sarah
312 Mary Jack Lowrie Dunlap, wife of Dr. David Dunlap
313 Unidentified
314 Dr. Pinckney Coatsworth Caldwell
315 Unidentified, probably student at Charlotte Female Academy boarding with Alexanders
316 Edward Hamilton Bissel

The Private Journal of Sarah F. Davidson, 1837

attempt to conceal her fatigue & desire of rest -- & Mr. B.[317] proposed to her that she should retire & leave us to entertain each other -- She did so & he remained until 12 o'clock -- Miss D[318] & myself then round up Matty[319] & procured some refreshment & retired – quarter past twelve

[Saturday, June 24, Home of Catherine Alexander]

24th Rose at my usual hour whilst dressing read some passages in Taylor's holy living & dying[320] -- After my devotional duties walked in the garden-- After breakfast practised some Duetts with Miss Dyott & then again to Dr. P. Caldwells he appear'd glad to see me -- & said Catherine & myself did him more good than all the men in Charlotte -- & wish'd me to remain with him & did so until Mrs. Blake[321] sent for me -- Sara Caldwell[322] & Mr. McComb[323] walked up street with me & call'd at Mrs Blakes — Mary[324] accompanied also to Mr Leavenworths[325] With whom I had a pleasant interview Mrs Q[326] & Miss P[327] – engaged in the School Room; we did not see them. Returned to Mrs. Blakes – after dinner marked some handkerchiefs[328] for her & about 3 o'clock we went to see Dr P[329] Call'd at uncle McCombs[330] – Jane[331] and Mary[332] walked with us – The Dr. was much depressed & restless – we talked cheerfully to him

317 Edward Hamilton Bissel
318 Miss Dyott, student at the Female Academy, living with the William J. Alexander
319 Matty, slave of William Julius Alexander
320 Jeremy Taylor (1613–1667). *Holy Living,* 1650 and *Holy Dying* 1651, are among the most famous examples of Anglican spirituality in English literature.
321 Margaret Blake, sister of Sarah
322 Sarah Roxanna Wilson Caldwell, wife of Dr. P.C. Caldwell and sister to Catherine Alexander
323 Probably Samuel McComb
324 Either Mary Davidson Elms or Mary McComb, both cousins of Sarah
325 The Reverend Abner Johnson Leavenworth
326 Unidentified
327 Miss Mary Ann Peabody, sister-in-law of Reverend Leavenworth
328 Embroidered initials
329 Dr. Pinckney Coatsworth Caldwell
330 Samuel McComb
331 Jane McComb Caldwell, wife of Green Washington Caldwell
332 Mary McComb

& before we left he appeared more composed. Most earnestly do I hope this affliction may be sanctified to him & that he may be brought to a right knowledge of himself as a sinner – repentance – submission & obedience to God May this power and beauty of the renewing grace of God be manifested in his life (if it should be spared) by softening & correcting the harshness & asperity of his natural disposition to which he has hitherto given a loose rein & being made anew in Christ Jesus – quietness docility – meekness - & loving kindness be manifested towards all with whom he may have intercourse At night attended prayer meeting – Much do I regret that is not in my power to attend punctually – I will endeavor to make my visits to my friends at such time as will enable me to enjoy this priviledge. –

25*th* Returned home before breakfast

[Monday, June 26, The Grove]
26*th* After tea whilst sitting at the pianno saw a carriage driving rapidly up to the door and was agreeabley surprised to find it was my sister M*rs*. Caldwell[333]--

[Tuesday, June 27, The Grove]
27*th* Accompanied my sister to Charlotte to visit some acquaintances. – Dined with Miss E. Watson[334] & then call'd to see D*r*. P. C. C.[335] – a little shower caused me to seek shelter under a tree by Catherines[336] gate – She saw me & sent an umbrella to me – but I found the tree protected me more from the rain than the umbrella if I left it – I therefore remained until the shower was over and was much amused on finding Catherine in another part of her yard also under a Tree. I found the D*r*.[337] mending slowly – I remained with him an hour & then returned with sister H[338] – to M*r*. Blakes[339] – M*rs*. Alexander[340]

333 Harriet Elizabeth Caldwell, wife of David Thomas Caldwell and sister of Sarah
334 Unidentified
335 Dr. Pinckney Coatsworth Caldwell
336 Catherine Wilson Alexander
337 Dr. Pinckney Coatsworth Caldwell
338 Harriet Elizabeth Caldwell
339 James H. Blake, brother-in-law of Sarah
340 Jane Henderson Alexander, mother of William Julius Alexander

The Private Journal of Sarah F. Davidson, 1837

her sister Marg[t][341] - & E. McComb[342] spend the evening with us After tea — M[r]. E. Bissel[343] Cap[t]. Morrison[344] & Brother William[345] call'd ---- My sister's little daughter[346] wandered out of the yard unknown to us — Some gentleman found her & not knowing her — concluded she was lost but she told her name & said she was not lost — D[r]. Boyd[347] suspected whose child she was & had her sent to M[r]. Blakes[348] — was ever much surprised & her mother quite alarmed she had twice during the day been brought home by different persons — but it was now night — It was not neglect of her mother — She had no nurse with her — (as Sarah Jane was four years old she deemed it unnecessary) -- & supposed her to play with the other children — but she being accustomed to a larger range than the small enclosure at M[r]. B's & attracted probably by seeing persons walking the streets to leave the yard. Mary[349] — Also came to see us after tea & stayed all night — H.[350] was watchful & could not sleep -- & expressed a wish for us to remain awake as she was much depressed --- I was exhausted from fatigue & want of sleep & could not, although I wish'd to comply. Mary & H. rose from bed & sat until nearly day I fear her melancholy is returning —

[Wednesday, June 28, The Village]

28th Went shopping — call'd on Catherine[351] — dined at D[r]. Boyd's[352] & spent the evening at D[r]. Dunlaps[353] — Mary accompanied us to D[r]. Boyds & sister Marg[t][354] to D[r]. Dunlaps — when we returned the servants told us M[r]. Watts[355]

341 Margaret Wilson, sister of Catherine Wilson Alexander
342 Elizabeth McComb, sister to Jane and Mary McComb
343 Edward Bissel
344 Unidentified
345 William Frew Davidson
346 Sarah Jane Caldwell, daughter of Harriet Davidson and David T. Caldwell
347 Joshua D. Boyd
348 James H. Blake, brother-in-law of Sarah
349 Mary Davidson Elms
350 Harriet Elizabeth Caldwell, sister of Sarah
351 Catherine Wilson Alexander
352 Joshua D. Boyd
353 Dr. David Richardson Dunlap
354 Margaret Davidson Blake, sister of Sarah
355 Unidentified

from Lincolnton had call'd left a letter & a box containing a plant of the hydrangia & geranium for me from my friend A. Ramsour[356] *-- on looking at the letter saw it was directed to a lady in Cabarras & hearing my brother say he was at Mc. Irwin's*[357] *– sent the letter to him to enquire if he had not left it by mistake – He examined it & sent the right one saying he would be over in a few minutes – He came accompanied by Mr. Blackwood*[358] *– After an hour's of pleasant converse they left —.*

[Thursday, June 29]

29th My brother accompanied me home. Engaged in domestic duties.

[Friday, June 30, The Grove]

30th Sent the carriage for Mrs Blake[359] *and Mary*[360] *Soon after they arrived Mrs Dunlap*[361] *& her daughter*[362] *drove up – they remained until after tea – Margt.*[363] *Bc. B*[364] *- & children – Mary*[365] *& Brother William remained all night.*

356 Adeline Ramsour

357 John Irwin, co-owner of Irwin and Elms store

358 John J. Blackwood

359 Margaret Davidson Blake, sister of Sarah

360 Mary Davidson Elms

361 Mary Jack Lowrie Dunlap, wife of Dr. David Dunlap

362 Harriet N. Dunlap

363 Margaret Davidson Blake

364 James H. Blake

365 Mary Davidson Elms

Editors' Annotation
July 1837

Several times during the month of July Sarah remarked upon the wonders of nature: a brilliant rainbow, the aurora borealis and the sun setting beneath the clouds. The Salisbury, North Carolina *Watchman* in its July 8th edition described the aurora borealis in great detail. It told of gathering and shifting clouds hovering then expanding over the horizon, illuminated by streaks of changing light and color. "In a moment the scene was changed... the pale greenish screen assumed a reddish sandstone color, the rays came again, whiter and more distinctly illustrated; the clouds around assumed a deeper hue until they were of a blood red cast." Lightening struck though the clouds "almost every second, in distant flickering corruscations, and seemed to rejoice as if its jubilee had come." The scene was "as varied and fantastical as the pictures of a Kaliedescope," green, blue, orange, various shades of red, "all of the colors of the rainbow." Clouds prevented Sarah from having such a magnificent view.

Sarah wrote of a conversation with Mr. Bissell concerning the intellectual inferiority of Africans, very revealing of nineteenth-century thinking. She reflected that Egypt, an ancient seat of wisdom and knowledge, had been enfolded in the darkness of ignorance, possibly due to the curse of Canaan and Ham. This was the biblical explanation of the Negroes' degraded condition making them incapable of deep learning, and in need of continual guidance, a common justification for slavery. "But if poor in worldly wisdom," she wrote, "may they be made rich in the knowledge and love of God."

Another day she reported how difficult it was to entertain when the usual house servants were away, and she had to direct slaves to which she

was unaccustomed. She fretted that she had to ignore her guests to attend to "the duties of the home" presumably the preparation and/or serving of a meal. Later she noted that these exertions were a lesson learned, and vowed to be less spiteful and irritated. Doing the work herself was noble, and more efficient than directing servants.

There is a two week break in the journal, from July 7 to July 21. She seemed to regret the inattention, but does not explain it. After another break of a few days she wrote: "Various engagements has made another chasm in my journal."

Toward the end of the month she wrote several times of the public examinations at Reverend Leavenworth's school, the Charlotte Female Academy. Most schools held examinations in which students would demonstrate their accomplishments before an audience. They consisted of dramas, recitations and musical programs. During this time Mr. McDowal, a tutor at Sugar Creek Academy, was invited to give a lecture on female education. He may not have been well versed in the topic, as Sugar Creek was an all boys' school. In any event, Sarah described the talk as "a mixture of bombast and buffoonery."

She described another visit to the mint, apparently to the public rooms. This time a portfolio of prints pleased her greatly, unlike the paintings she had seen there in June. She described the prints as landscapes, reflecting her love of nature.

July 1837

[Actually, Saturday, July 1, The Grove]

31ˢᵗ All busily engaged in sewing – about 11 o'clock Mʳ. Bissel³⁶⁶ drove up in his buggy --- He came charged with a message from Mʳˢ. A³⁶⁷. wishing me to go in & said he would call for me at 3 o'clock. Margᵗ ³⁶⁸ Mary³⁶⁹ & the children left after dinner & at the appointed time Mʳ. B³⁷⁰ came – We had a pleasant ride until we got in the open grounds of Mr. Irwin's³⁷¹ through which the road passes – the atmosphere was still -- & the rays of the sun oppressively hot – he drove rapidly & to avoid the Sun Passed around the mint³⁷² through the open field at the back of the Village which was nearer than if we had taken the usual route through the Village — He spoke of the intellectual capacity of the human race – as evinced in national character & convinced me that the Africans are inferior whether it is their ignorant degraded condition --climate -- or the curse entailed on the progeny of Canaan or Ham it is not easy to determine. Egypt was at one time the seat of wisdom & learning: When the night of ignorance hovered o'er all other lands -- there the light of science

366 Edward H. Bissel
367 Catherine Wilson Alexander
368 Margaret Davidson Blake, sister of Sarah
369 Mary Davidson Elms
370 Edward H. Bissel
371 John Irwin
372 Branch of the U.S. Mint

A Life in Antebellum Charlotte

showered downward & emitted rays of such power that all who thirsted for the light of knowledge sought -- obtained -- & reflected -- & thus emitted to their own land - the peculiar privileges of their requirements – Then the night of ignorance slowly appeared & enveloped in its dark folds the foundation so distinguished for learning & wisdom until it is now in such a miserable -- low -- degraded condition -- its inhabitants some are not admitted to be of capable of receiving instruction in the very sciences which [words crossed out] originated on their native soil --- But if poor in worldly wisdom --- may they be made rich in the knowledge & love of God. by the instrumentality of the missionaries now laboring for their spiritual good ---. --- Soon after I arrived at Catherines[373] a refreshing shower cooled the atmosphere – Whilst at the window and as the rain eased a brilliant rain-bow was reflected – undivided -- & appeared very near us --

After Tea M^{rs} Dyott[374] was with us -- about 9 – o clock Miss D[375] & myself accompanied her to her boarding house -- as we returned the stage passed us -- We amused ourselves a while at the Pianno & then retired to C' chamber -- the servant brought in letters & papers -- whilst reading -- one of the servants call'd me to the window to see an unusual light in the element -- it was the Aurora Borealas[376] -- I call'd Catherine & we gazed until it faded away -- or disappeared -- -- In the course of a few hours -- we had witnessed two of the most brilliant phenomena's of Nature -- & in each we can but adore the goodness & Mercy of God ---- His first His beautiful & indelible seal or token of His covenant with man to preserve our earth from another deluge -- although the manifold wickedness which dayly arises -- offensive to His pure eyes in whose sight even the Heavens are unclean -- Yet His faithfulness is unwavering -- with tender mercy He regards us -- & crowns each day of our lives with enumerable blessings -- Oh how basely ungrateful are we the recipients of His loving kindness -- Oh Lord create our hearts anew & renew a right spirit within us -- I might write out the various thoughts that presented themselves merely as situations to pheonomena but I have not yet fully digested & arranged them -- The Aurora Borealis was not very brilliant as it was a cloudy night -- I would like much to see it when in all its splendor -- it sheds light upon that portion of the Globe -- divested of the suns rays for months -- in which God has centered the

373 Catherine Wilson Alexander
374 Unidentified
375 Unidentified
376 The Salisbury, North Carolina newspaper, *The Carolina Watchman*, records this event.

The Private Journal of Sarah F. Davidson, 1837

great vivifying power of light & heat, -- To what extent does it supply the natural light -- This is a subject for me to investigate -- I will therefore not waste time &c &c -- by random sketches.

[Sunday, The Village]

July 2nd –Sabbath School -- To day I commenced a new class consisting of Sarah[377] -- Mary[378] & Catherine Alexander[379] My friend Catherines daughters & her little sister Mary G. Wilson.[380] To day Mc L[381] -- gave us quite a patriotic sermon --to the surprise & delight of his audience – May those who have hitherto only considered the liberty of their country -- & the celebration of its consummation -- Be now inspired with love to Him who has given us the liberty of the Gospel by His own power & might & His praise be the theme of every tongue. Until the joyous sounds shall echo & echo from land to land. -- & the whole earth be filled with the knowledge & love of God in Christ our Lord. It was late when I returned home -- the western horizon was cover'd with clouds ---- that resembled the waves of a troubled sea -- their foaming crests tinged as it were with burnished gold by the rays of the setting sun [words crossed out] from behind the clouds issued a stream of mellow light -- & descended in a limited space to the South east -- The setting & rising sun with their splendid heraldry & attendant clouds is ever an object of contemplation -- to me most delightful -- I feel their beauty -- but when I attempt to deliniate by even a passing description -- I feel the poverty of my imagination unless I clothe it in the language of other's -- <u>which</u> I can not stoop to.

[Monday, July 3, The Grove]

July 3rd Engaged in domestic duties -- about 5 o-clock accompanied by Lawson[382] rode to my sister[383] -- found her better and & more cheerful --

377 Sarah Elizabeth Blake, age nine, daughter of Margaret Blake
378 Mary Wood Alexander, age nine, daughter of Catherine Wilson Alexander
379 Catherine Wilson Alexander, age six, daughter of Catherine Wilson Alexander
380 Mary G. Wilson, age eleven, Catherine Wilson Alexander's sister
381 Rev. Abner Johnson Leavenworth
382 Lawson, carriage driver and slave of William Davidson
383 Harriet Elizabeth Davidson Caldwell, sister of Sarah

A Life in Antebellum Charlotte

[Tuesday, July 4, The Grove]

4*th* *Indisposed -- whilst lying in the bed -- Catherine*[384] *carriage drove up -- Mary Elms was with her they were seated in the Parlour before we knew they had come. -- We spent a social day & I then rode with her to Town expecting Lawson to meet me there with a horse -- I was disappointed -- spent the night with Mary*[385] *& returned home before breakfast next morning –*

[Thursday, July 6, The Grove]

*6*th *Engaged writing letters -- & making ketshup*[386] *for myself & sister Marg*t*.*[387]

[Friday, July 21, The Grove]

*21*st *Two weeks have passed -- their hours & days are mingled with the incureable past -- & what have I done towards a preparation for the time when I shall be numbered amongst the things that were -- on earth -- for I trust I shall live in heaven -- Yet it is to grace divine I only ever look & therever feed my hope of Eternal life -- Alas how weak & erring I am – fill'd with vain & foolish thoughts & desires -- Our natural hearts are founts of corruption & yet how little we strive for their purification & to the mind enlightened by truth divine whenever a greater source of pain & unhappiness -- Oh Lord My sinful thoughts & feelings are Thy sorest evils – Thou alone hast power -- & unto Thee I look for deliverance create my heart anew -- & purify & sanctify me & make such as Thou wouldst have me to be. My Sisters have been with me this week -- Here again is a theme for thanksgiving & praise to our Almighty & Heavenly Father -- who has preserved us as a family & provided for us all things needful & expedient to which He has added other innumerable blessings. Low our afflictions He has made*

"Like the plants that throw
Their fragrance around the wounded part
Breathes sweetness out of wo!"
--
 *Yesterday morning the (20*th*)* [Thursday, July 20] *I was surprised with*

384 Catherine Wilson Alexander
385 Mary Davidson Elms
386 A sauce made of various ingredients, mushroom ketchup was popular at the time.
387 Margaret Davidson Blake

The Private Journal of Sarah F. Davidson, 1837

a visit from Mrs. B Alexander[388] & Mr Strange[389] -- Miss Dyott[390] & my Brother[391] -- Mary McComb & Mr & Mrs Harris[392] - They remained until after tea -- I was delighted to see them & so labored to entertain them as well as I could -- but my servants were from home & I was compell'd to leave my company to attend to the duties of the home &c &c The disobedience & insolence of one of the servants irritated me & rendered me very uncomfortable until my own exertions supplied the absence of the house girl that was away I hope I have derived a salutary lesson from this circumstance -- which is -- when similarly situated not to suffer my temper to be [illegible] - spiteful or irritated & to put forth my own hand which can do better & quicker my desire than a servant can by direction.

[Probably Saturday, July 22, The Village]
The 12th Mrs B[393] & myself visited Mrs C[394] late in the evening we returned --from town-- I was accompanied home by my Father & Mr McComb[395] As we approached "The Grove" -- the Sun had set – but the western horizon was lit up with a bright, [words crossed out] & glowing red-- which contrasted beautifully with the distant & more delicate tints -- & the whole was rendered more beautifully picturesque by [words crossed out] the peculiar position we occupied-- Various engagements has made another chasm In my Journal

[Tuesday, July 25, The Grove]
25th A visit from Ivor --

388 Elvira Davis McCoy Alexander, wife of Benjamin Wilson Alexander
389 William F. Strange, clerk of the U.S. Mint at Charlotte
390 Unidentified
391 William Frew Davidson
392 Thomas J and Elizabeth Locke Harris
393 Margaret Davidson Blake, sister of Sarah
394 Harriet Elizabeth Davidson Caldwell, sister of Sarah
395 Samuel McComb

A Life in Antebellum Charlotte

[Wednesday, July 26, The Grove]
*26th Col*c *Wheeler*396 *&* *M*c *M*c*Comb*397 --

[Probably Thursday, July 27, The Village]
*28th Rode on horseback to the Village -- call'd on the Misses Burton*398 *-- spent the morning very pleasantly --- with Catherine*399 *-- Miss Blondel*400 *-- Miss Burton*401 *-- M*c *Bissel*402 *-- M*c *A*403 *-- & D*r *Longstaff*404 *-- the last was rather a cipher in my estimation – or rather an excrescence - that obtruded itself = A deformity is ever conspicuous In the afternoon accompanied by Miss M Lowrie* 405 *went in the carriage to D*r *Caldwell's*406 *to bring my sister M*rs *C.*407 *to the Village. M*c *Leavenworths*408 *examination had commenced -- & M*c *McDowal*409 *who boarded with her was to deliver an address or lecture on Female education -- He rode with us to town -- After Tea M*c *Leavenworth call'd & chatted with us until the bell summoned us to the Lecture. I walked with M*c*. L-- telling him as Mrs. L -- was absent I would take possession of him as my escort. I did not have my expectations excited by anticipations of eloquent* [words crossed out] *chaste style of composition -- or indeed any thing particularly interesting -- but I did not either expect to hear -- what shall I term it -- a mixture of bombast & buffoonery -- & concluded With a*

396 John Hill Wheeler, superintendent of the U.S. Mint at Charlotte
397 Samuel McComb
398 Unidentified
399 Catherine Wilson Alexander
400 Caroline Blundell, daughter of English mining-investor Henry Blundell (Anglo American Gold Mining Association)
401 Unidentified
402 Edward H. Bissel
403 William Julius Alexander
404 George Dixon Longstaff, English mining-investor (Anglo American Gold Mining Association)
405 Margaret Alexander Lowrie
406 Dr. David Thomas Caldwell, brother-in-law to Sarah
407 Harriet Elizabeth Davidson Caldwell, sister to Sarah
408 The Reverend Abner Johnson Leavenworth
409 Robert Irwin McDowell, precept at the Sugar Creek Academy

The Private Journal of Sarah F. Davidson, 1837

tirade of the grossest compliments to M̄ L. & family. After we returned home – M̄. Elms[410] call'd for M[411] & as we sat chatting in the Portico -- Friend Ivor[412] joined us -- M̄ E[413] & M left & I {Ivor} & myself remained chatting -- I know not to what cause to attribute my extreme loquaciousness when with him -- unless it is my confidence in his friendship the sincerity of which he gave an excellent test when last here -- by pointing out some errors I had committed in writing a few lines of Poetry in an letter In two lines there were 4 errors -- It astonished me I thank him most sincerely -- It has forced a lesson of humility and charity --. How unmerciful I have been on similar occasions -- . From this time I must be more watchful -- & know that I too may were (in things of which I am not ignorant of) through carelessness -- or inadvertency -- & criticize with less severity the errors of other's.

[Probably Friday July 28, The Village]
29ᵗʰ Call'd at Catherines[414] to say farewell to Miss B.[415] M̄ A[416] came in & ask'd me tie a mourning badge on his arm -- I did so & also arranged M̄ Osborns[417] -- It was a token of respect to F. L. Smith.[418] Alas -- alas how uncertain are the promises we fill our minds with instead of strength & joy -- Sighs in desolation too frequently result -- Poor F. left his home -- his native home -- Mother & Sisters -- & with his young wife & infant child sought a more southern clime in search of wealth & fame -- Little more than six months has elaps'd since he departed -- & now where is he -- numbered with the Dead -- His widowed wife[419] & orphaned son -- in a land of stranger's. The particulars of his death has not been receiv̄. M̄ A.[420] requested me particularly to be at his house in the evening. I then left to attend the examination. Dined with Dʳ. & Mʳˢ. Harris[421] -- Mary & M̄.

410 William W. Elms
411 Mary Davidson Elms
412 John J. Blackwood
413 William W. Elms
414 Catherine Wilson Alexander
415 Either Miss Blondel or Miss Burton, possible students at the Female Academy
416 William Julius Alexander
417 James Walker Osborn, attorney
418 Franklin L. Smith
419 Isabella Torrance Smith
420 William Julius Alexander
421 Elizabeth and Thomas J. Harris

Elms after dinner again attended the examination. -- & in the evening repaired to M̄ A. -- It was late. M̄ A. was dressing -- & I retired to a room to arrange my hair &c. &c. Miss Dyott[422] came to my room & being ready we descended to the drawing room -- but neither had the courage to enter. We finally went into the Piazza. -- Where we found D̄. P. C. C[423] & Roxanna[424] --. Catherine call'd me & after walking in the Passage a while entered the drawing room & was introduced to M̄. Goring.[425] -- M̄. B[426] I took a seat on the sopha & M̄. B came up & addressed me very formally but his countenance was the same & the chill that was creeping over me at the unusual sound of <u>Miss Davidson</u> (from him) was relieved Miss Dyott joined us & we enjoyed a social chat until Tea was announced. After Tea M̄ A. would have me seated at the Pianno -- But from this I was soon relieved as we all wish'd to attend the concert given by M̄. S.[427] -- of M̄. L[428] school -- . -- I did not return to M̄ Alexander's as it was late when the concert was concluded -- Set up most of the night with M̄ᵃ B[429] my sister who suffered much from a nervous toothache.

[Probably Saturday July 29, The Village]
 30ᵗʰ Rec'd a call from Miss Dyott. Dined at D̄ P. Caldwell. -- Call'd on M̄ᵃ Dyott -- & M̄ᵃ Smith[430] -- & in the afternoon walked to the Mint. where I enjoyed myself very much by looking over a Portfolio of prints. Col̄ Wheeler[431] the superintendent was absent -- We of course could not see much of the building or machinery & as some amused themselves at the Pianno others by looking at the furniture -- &c. &c. I fortunately pounced upon his Portfolio -- I was so delighted with the treat I found I call'd the other's to enjoy it -- with me. But I found none who looked and felt with me. -- When a view a landscape well delineated my imagination transports into the scene nature sketched before me -- & I almost realize their native beauty in all their animated characteristics -- [words crossed out] After Tea Mary McComb & Col̄

422 Unidentified, probably student at the Charlotte Female Academy
423 Dr. Pinckney Coatsworth Caldwell
424 Sarah Roxanna Wilson Caldwell, wife of P.C. Caldwell
425 Unidentified
426 John J. Blackwood
427 Unidentified
428 The Reverend Abner Johnson Leavenworth
429 Margaret Davidson Blake
430 Possibly mother of Franklin L. Smith
431 John Hill Wheeler

The Private Journal of Sarah F. Davidson, 1837

Wheeler call'd -- Mary remained all night with me she has made me the confidant of all her little troubles & looks upon me as a friend as well as relation. May I never abuse her confidence -- but with all sincerity hold sacred the trust reposed in me. We sat talking until 12 o-clock. How this affair will terminate we can not tell. I wish M. had no part in it.

[Probably Sunday July 30, The Village]

31ˢᵗ Attended Sabbath School & felt myself particularly strengthened & prepared for teaching & never did I discharge the duty of teacher with so much satisfaction to myself -- My pupils were very attentive -- & conducted themselves with becoming solemnity. All thanks & praises unto The Holy Spirit who aided me in the discharge of my duty -- & put into my mouth solemn injunctions to speak to the young immortals in my care -- They leave for the mountains on the 3ʳᵈ of August and I may never see them this side of the grave But my prayer to Thee Oh God = is that we may meet at Thy right hand on high. Make each one of them subject of Thy renewing grace -- and may they become faithful & zealous laborers in Thy [illegible] on earth and when they have finished what Thou hast for them to do here -- receive them into Thy mansion above -- to worship Thee in the beauty of holiness & sing the praises of Redeeming love throughout the countless ages of Eternity. After the school was dismissed had the pleasure of an introduction to Col. Lemly[432] -- of Salisbury. The friend of M. B.[433] The friend of my friend -- & therefore mine -- he would say -- but it does not always hold good. After teachers meeting returned home -- M. A. Irwin[434] rode with me to her fathers farm. – She leaves on Tuesday for N. Y. She appeared to think I had slighted her -- After mutual explanations we renewed our profession of friendship -- kissed and bid each other farewell. –

432 Unidentified
433 John J. Blackwood
434 Mary Ann Irwin, daughter of John Irwin

Editors' Annotation
August – October 1837

Sarah's entries during the last few months of her journal were sparse. She began the month of August in a gloomy mood, although she did find pleasure in "reading Good's book of nature." Then disagreeable weather set in, which seemed to augment her depression. Her next entry was two weeks later relating that a visit with Reverend Leavenworth had lifted her spirits. She seemed to be her old self for a few days, visiting in the village, dining with friends, etc., but her depression returned and once again she became worried about the state of a friend's soul. This time Edward Bissell was the object of her concern.

She reported her father's birthday in two entries, both dated Sept. 2. They are followed by two entries dated August 31. These were probably written early in September, but were dated August 31 because that is the day they describe.

The next and last entry was made on October 11. She said "I have done little else for six weeks but nurse the sick." She recalled some of the people she had tended, black and white, including several who died. Fatigue, poor health and mental duress were constant companions.

She was dismayed when a group of friends made a "fashionable" call, very uncharacteristic for Sarah. She did not feel well, and resented the dictates of fashion that required the prompt returning of social visits. She invited one of her callers, Anna Peal, to return on Friday (two days later). She vowed to then be less judgmental and "not wanting in polite attention." Anna Peal was with her father Franklin Peal, a construction supervisor, who was in Charlotte to inspect the construction of the Mint. His father was the famous artist Charles Peal.

A Life in Antebellum Charlotte

The last page of the book contains an entry made June 13, 1836, a full six months before she began the journal. It is probably a random comment made of a notable day, and not meant to be part of a continuing record. The last few lines, which appear to be in her hand, address a religious question and are written in pencil.

There is only one blank page at the end of the journal indicating Sarah may have continued to record her life in another volume. Or she may have wearied of the project. The last entries lack her customary regularity and enthusiasm.

August–Ocotober 1837

[Tuesday and Wednesday, The Village]
1st & 2d of August - Engaged in sewing -- &c mind not at ease -- & struggling to be so. Oh this world with its fleeting and evanescent[435] joys --- deluding & deluded yet we yearn still -- Oh my soul -- yearns for the love of God & then with be content -- Oh that every vacuum in my heart were filled with the love of God.

[Thursday, August 3, The Grove]
3d Sewing all morning -- In the afternoon ordered the Carriage & rode to the Village to see Mrs D. Alexander[436] -- she was sitting out -- & I did not see her --. I remained until after Tea Call'd on Mrs B,[437] -- & then returned to The Grove

[Friday, August 4, The Grove]
4th Reading Good's book of nature.

[Saturday, August 5, The Grove]
5th Do -- Do --- I find the perusal of this work truly profitable. In addition to the information recd it elevates the mind -- stimulates all the intellectual faculties & makes man what God created him & a rational & intelligent creature -- A

435 Evanescent, tending to vanish like a vapor, transient
436 Annabella, wife of Dan Alexander
437 Margaret Davidson Blake

A Life in Antebellum Charlotte

Thinking Being. ------- *Although we may be the lowest link in the everlasting golden chain of intelligence -- let us not by voluntary ~~not~~ sink below the created creatures over which man was made to rule. -- but strove with all the energy with which we are endowed to fulfill the end for which we were created & ascribe all the power and glory to God in whom we live & move & have our being.*

[Sunday, August 6. The Grove]

6th An unusual change in the weather – Raining & the atmosphere so damp & cold – renders a fire necessary to be comfortable. Fire kindled in the Hall[438] & my chamber[439] -- only 2 days ago the heat was excessive -- some degrees above Summer heat. Languid -- with an oppression about my heart [illegible] *& superstitions I would say a prescientiment of trouble or some evil not apprehended. It ways upon my spirits -- & my whole system is heavy & dull -- August I have heretofore considered the hottest of our Summers month -- but observation found it to be one of the most variable -- cold nights much rainy & damp weather -- with occasional hot days extremely oppressive and enervating to the system -- Which I* [illegible] *as the prominent cause of my depression. As our good Pastor tells us – we should only sorrow for Sin & indeed Sin is the origin of sorrow – oh that my sorrow were always of a godly sorrow.*

[Sunday, August 20, The Village]

20th Attended Preaching & had my mind & feelings refreshed with spiritual food – Spent this night with M^r Leavenworth's[440] family -- & here again was I regaled with the pious conversation & reading of M^r. L and my spirits almost regained their usual elasticity -- cheerfulness & calmness. Next morning accompanied by Miss P.[441] Call'd on M^{rs} Smith[442] the mother of F whose death is recorded on a previous page from there to Aunt M^cComb[443] & M^r [illegible] *Miss P -- then returned --- Friend Ivor[444] called & I fear I did wrong in making the communications to him relative to some*

438 A room, not a passageway

439 Bedroom

440 The Reverend Abner Johnson Leavenworth, minister of the Presbyterian Church at Charlotte

441 Mary Ann Peabody, sister in law of Reverend Leavenworth

442 Mother of Franklin L. Smith

443 Alice Brandon McComb

444 John J. Blackwood

The Private Journal of Sarah F. Davidson, 1837

secret transactions but I have full confidence in his honour -- Yet I would that I had been silent –

[Wednesday, August 23, The Grove]

23ᵈ Mary[445] – William[446] – Franklin & his wife dined with me -- In the afternoon Mʳ & Mʳˢ Leavenworth & Mʳˢ Peabody[447] came & remained until after Tea. –

[Thursday, August 24]

24ᵗʰ I went to the Village -- dined with my sister[448] -- & took tea by particular invitation with Mʳ & Mʳˢ L. & returned to The Grove early next morning. Remained in town for the night sermon. My Brother & Mʳ. McComb[449] returned with me. Again depressed painful doubts – my whole system -- mind & body -- uncomfortable. Mʳ Wilson[450] came out for Mary[451] -- & soon after Mʳ Bissil[452] called & passed some hours with me. As usual he was -- entertaining & instructive in his conversation but alas -- it is only relative to time -- Oh that he were living for Eternity. Oh Heavenly Father –deign to listen -- & grant my petition for this -- my brother of mankind -- & by Thy power make him subject to Thy Laws divine -- through willing obedience & Grant that I may begin the blessed enjoyment of hailing him as a brother in Christ -- & seeing the power of intellect wherewith Thou hast endowed him -- consecrated Thy service.

[Saturday, September 2, The Grove]

Sepʳ 2ᵈ My fathers birthday -- 59 years have been emerged in the gulfts of time since he was ushered into this world of cares, troubles, & joys. -- (& our joys would outnumber our cares & troubles – did we rightly appreciate the dispensations of our great Benefactor – which are ever the result of His unerring wisdom & infinite benevolence.) – ~~He is the last son of his parents~~

445 Mary Davidson Elms
446 William W. Elms
447 Elizabeth Manning Peabody, Mrs. Leavenworth's mother
448 Margaret Davidson Blake
449 Samuel McComb
450 Unidentified
451 Unidentified
452 Edward H. Bissel

being disturbed my train of thought was broken
[verse written in pencil:]
> *Go Little volume like the Bee*
> *Each fertile field of mind explore*
> *cull from each mortal shrub or tree*
> *Some grateful sweets to swell thy store.*[453]

Like singal [written in another hand]

[Saturday, The Grove, day repeated]
Sep^{tr} 2nd My father's birth day –

August [These entries written after Sarah returned home may have been written in September.]

[Thursday, August 31, Elms home]
31st I have been nursing Mary[454] *for the last two nights –*

31st I have been staying with M Elms since Tuesday. She is better - & - I am again in my own domicil – Friend Ivor[455] *accompanied me. – by request – It is the last day of summer – How many sensations crowd about my heart – at the sound –*

[Wednesday, The Grove]
October 11th These records manifest – disturbed & broken thoughts - & yet a glance recalls to my own mind all the little circumstances that occurr'd – but not the reflections produced by those which I suppose were not well defined but like passing shadows left no sign that they had been. Since then I have witnessed much affliction – & have been borne down by fatigue & loss of sleep.
Rich^d [456] *– died 22nd of September – away from home & his friends – This circumstance distressed me & I rejoiced that I had remained with him as my presence*

453 Traditional poem of autograph books of the period
454 Mary Davidson Elms
455 John J. Blackwood
456 Possibly Richard, slave of William Davidson

gratified him & that it was also an alleviation to his old Parents. Francis Irwin[457] died on the 24th & on the next evening I was sent for to come home to see Richd. mother[458] – who was very ill – several others became sick – so that I have done little else for six weeks but nurse the sick – But I can but praise our great & almighty Protector that those very near & dear to me have this season been spared & blessed with health. Yesterday afternoon Colt Wheeler's[459] carriage unexpectedly drove to the door & out stepped the Colt M M McComb[460] Mr & Miss

They paid me a very fashionable call. I can not say I was displeased or regretted it--- I was quite unwell & did not expect them to return my call so soon. Oh how heartless are the votaries[461] of fashion. It does not suit my warm southern feelings & from the impulse of the moment I invited Miss P to return on Friday. She promised yet I shall be pleased if she does not come – I had given her credit for much good sense & good feeling –– the latter I fear was in my imagination –– but I will not judge until I see more of her. If she comes I will endeavour not be wanting in polite attention.

[This entry is out of sequence. It is dated June 1836, six months before Sarah began her juornal]

June 13th 1836 - Cousin Mathew[462] paid his farewell visit To us this morning – <u>Farewell</u> –how much is expressed And how much is <u>felt</u> in pronouncing this combination of two little words – it falls on the ear as the knell of association severed by removal of Friends for a time or for ----ever. God grant that this may be a parting to meet again – if not on Earth at His right hand on high. –

[Remainder of this page is in pencil]

The instructions of Mariam which according to Sr. W. Elms are as ancient as the writings of Moses - In the account of creation - defines - a day - a period of several thousand years - - its close resemblance to the account written by Moses is considered a probable evidence of its being derived from the same patriarchal communication.[463]

457 Francis Irwin, nineteen- year-old son of John and Mary Ann Irwin
458 Slave of William Davidson
459 John Hill Wheeler, superintendent of the U.S. Mint at Charlotte
460 Colonel Wheeler; probably Mary McComb; Mr. Franklin Peal, supervisor of the construction of the mint; and Mr. Peal's daughter Anna
461 votary, devotee or advocate
462 Probably Matthew McComb, who moved to Georgia
463 This is the explanation of the age of the earth that Sarah mentions.

Sacrament of the L[...]
[...] I can not describe
[...]ith pathetic eloquence
[...]aled the assembled m[...]
[...]ge to be reconciled to G[...]
[...] God to us in Christ
[...] melted — I long'd
[...]risen and confessed my
[...]ner of Jesus. —
[...] was firm and dec[...]

… suppose —. I will not

the emotions of my so[ul]

— as an ambassador for C[hrist]

ttitude especially than[ks]

d — dwelling particul[arly]

— under the power of

embrace Him — and we

eager and ardent des[ire]

Although from th[e]

ded to forget the thin[gs]

Epilogue

In 1839 Sarah's beloved teacher Mrs. Hutchison opened a Female Academy in Charlotte, and Sarah became its piano instructor until 1847. She was Superintendent of Music at the academy from 1847 to 1850, and became Superintendent and Principal in 1850. Her father's financial reverses that are alluded to in the journal probably necessitated her employment. During his later years much of his property was mortgaged. One can only hope Sarah's dissatisfaction with music students that she mentioned in the journal was short-lived.

In 1839 her sister Margaret Blake died, and Sarah assumed partial responsibility for raising her young nieces; two of them were living with Sarah and her father in 1850.

In 1845 her sister Harriet Caldwell died, a victim of an erysipelas epidemic that also took three of her children. Sarah may have assisted her brother-in-law with the remaining five children, although they continued to live in their own home.

Sarah's father, William Davidson, died in 1857 after being thrown from his carriage. He was 79 years old.

In 1860 Sarah was living in Gadsden County, Florida at the home of her niece Harriet Josephine Blake Davidson and her husband Joseph Sylvester Davidson. Harriet's sister Mary Margaret was also a member of the household. Joseph Davidson supported the extended family as a druggist. He had been born in Florida, although his ancestral home was Mecklenburg County. When Harriet died in 1861, Sarah and the rest of the family returned to Charlotte.

Sarah died in Charlotte on May 2, 1889, at the age of eighty-five and is buried there in Settler's Cemetery.

Biographical sketches

Susan Nye Hutchison (1790–1867)

Susan Nye, an unmarried lady of twenty-five years, left her rural village of Amenia, New York in 1815 for Raleigh to become a teacher of young ladies. During her seven-year-tenure at the Raleigh Academy she taught Sarah Frew Davidson and her sisters, Margaret and Harriet. Next Susan moved to Augusta, Georgia to open her own school. While in Georgia she met and married Adam Hutchison, a widower with three children, and over the next seven years gave birth to four sons. Economic hardship and her husband's poor health caused her to return to New York with her children, and while she was there her husband passed away at a Florida spa where he was seeking a cure, probably for tuberculosis.

 She taught for a while in her hometown, then left her children temporarily with her parents, and once again returned to Raleigh to teach. A year later in 1836 she began teaching in Salisbury, which seemed a more profitable opportunity. This is when she revived her acquaintance with Sarah Frew Davidson and her sisters, her students of two decades before. It was Susan who encouraged Sarah to keep a journal. Susan herself was an exemplary diarist. Her surviving journal, in the Southern Historical Collection at The University of North Carolina Library in Chapel Hill, spans 1815 to 1841 with few breaks. Along with daily trivia Susan recorded personal and family struggles, a difficult marriage

and exhausting and often treacherous travel. However, education and religious matters are its overriding theme. Like Sarah, she frequently worried that her faith was neither strong nor pure enough, and expressed concerns for the salvation of friends and family.

In 1839 Susan opened a school for young ladies in Charlotte. Entries from her journal tell us that her friendly relationship with Sarah and Sarah's extended circle of friends continued until the journal's end in 1841. Susan eventually returned to Amenia, New York where she died in 1867.

John J. Blackwood (1810–1881)

John Blackwood was born in Hillsborough, North Carolina. In 1837, the year of Sarah's journal, he was twenty-seven years old (six years her junior), and living in Charlotte. Sarah does not mention his occupation, however, he was very active in the Presbyterian Church and the Sabbath school movement. He and Reverend Leavenworth were Sarah's mentors in managing her Sabbath school classes.

John Blackwood was the "Ivor" who wrote the introduction to Sarah's journal. Throughout the journal she referred to Ivor as a cherished friend and inspiration. Susan Nye Hutchison's journal mentioned Blackwood several times in 1837, including a correspondence with him that coincided with Sarah's report that "brother B." had received a letter from Mrs. Hutchison. In that letter Mrs. Hutchison complimented him on the elegant introduction to Sarah's journal. Several times Sarah used the words "brother" or "sister" in a religious sense rather than a familial one.

Sarah used the names Ivor, Mr. Blackwood and brother B. interchangeably, and with pleasant familiarity remarked how easily she conversed with him. Sarah may well have had a crush on the young man, and was probably disappointed that he did not return her affections.

Blackwood had a long career in banking which was probably underway during the period of Sarah's journal. In July of 1836, he was listed as

trustee on a deed of trust for William Davidson's land and slaves, property Davidson eventually lost. Blackwood may have represented the interests of a bank in that capacity.

When Mrs. Hutchison moved to Charlotte in 1839, Sarah and Mr. Blackwood were frequent visitors in her home, drinking tea and playing music. Sarah became a music teacher in Mrs. Hutchison's school, and Mr. Blackwood a deacon in the church. Mrs. Hutchison's journal ended the first of January 1841, and did not mention Blackwood's marriage plans. Sometime that year he married Mary Laura Springs, daughter of Eli and Tirzah Ball Springs. Their only son was born in September of 1842. Blackwood's banking career took him to several South Carolina towns. At one point he may have worked with one of Mrs. Hutchison's relatives. In 1861 he became the president of the Bank of Charlotte. He died in Charlotte in 1881.

The Reverend Abner Johnson Leavenworth (1803–1869)

Abner Johnson Leavenworth was born in Waterbury, Connecticut to the well-known physician Dr. Frederick Leavenworth and his wife Fanny Johnson Leavenworth. On June 14, 1831, Leavenworth married Elizabeth Manning Peabody (1809–1841), daughter of John and Elizabeth Manning Peabody. That same year he began work at the Presbyterian Church in Charlotte as a supply minister. From 1831 to 1834 he probably filled in at the Charlotte church for the Reverend Robert Hall Morrison on the Sundays Morrison was preaching at Sugar Creek Presbyterian. Leavenworth became the full time minister at the Charlotte church in 1834. Sarah described Reverend Leavenworth's sermons as excellent, and one she particularly enjoyed was calculated to induce self-examination. Leavenworth was one year older than Sarah. He became her friend as well as her spiritual advisor. Sarah admired her minister's intellect as well as his piety and enjoyed being in his company. After visiting The Grove to minister

to the dying Amanda, one of the Davidson slaves, Leavenworth was invited to stay for tea. Sarah highly enjoyed his intellectual conversation.

In 1832, in addition to his ministerial duties, Leavenworth and his wife began superintending the Charlotte Female Academy, which operated under various names. Advertisements in the *Miners and Farmers Journal* listed such subjects as English, Latin and French. Many of Charlotte's elite young ladies attended this academy. Sarah's intense admiration for the young minister was not shared by some of his students who found him stern and demanding. Elizabeth Leavenworth's sister Mary Ann Peabody joined the Leavenworths in Charlotte to assist with the school.

Reverend Leavenworth left Charlotte in 1838 for Warrenton, Virginia where he took charge of a young ladies academy. In 1840 he was called to a New School Presbyterian church in Petersburg, Virginia. In 1844, the Leavenworth Academic and Collegiate Seminary for Young Ladies was established, which acquired an excellent reputation throughout the south. Abner Leavenworth with the help of his sister-in-law Mary Ann Peabody operated this school until his death in 1869.

Reverend Leavenworth was an accomplished writer, and was appointed corresponding secretary for the Virginia educational association.

Catherine Wilson Alexander (1805–1884)
William Julius Alexander (1797–1857)

Elvira Catherine Wilson Alexander, called Catherine, was Sarah's closest friend. Daughter of Mary Wood and Joseph Wilson, Catherine was born on October 17, 1805. Her father, a leading lawyer in the village of Charlotte, maintained an office next to the Davidson town home on the square. Sarah and Catherine knew each other most of their lives and probably played together as children. They both attended the Raleigh Academy under the tutelage of their beloved "preceptress" Susan Nye

The Private Journal of Sarah F. Davidson, 1837

Hutchison. Sarah and Catherine's initials were among those engraved on the back of a medallion given to Mrs. Hutchison by her former students.

Catherine married William Julius Alexander on December 7, 1824. William Julius, born in Salisbury, North Carolina to Jane Henderson and William Lee Alexander, attended Poplar Tent Academy and graduated from the University of North Carolina in 1816. After an apprenticeship with his uncle Archibald Henderson of Salisbury, he was admitted to the North Carolina State Bar in 1818.

By the time of the journal in 1837, Julius had become an influential citizen of Mecklenburg County where he was active in politics and the practice of law. Between 1826 and 1835, Alexander served a total of seven terms as the representative from Mecklenburg County to the North Carolina House of Commons. For three of those terms, he served as speaker of the house. In 1829 Alexander was appointed solicitor for the 6th Circuit Court, a position his father-in-law Joseph Wilson had held until his death. Julius held the position of solicitor until 1833 when he resigned. Not always successful in his pursuit of a political office, he was defeated in his bid for a seat on the North Carolina Superior Court in 1835.

Catherine most likely had also experienced an evangelical conversion, as Sarah did not express concern over the state of Catherine's soul. Catherine and Julius were active members of St. Peter's Episcopal Church which worshiped in conjunction with the Charlotte Presbyterian congregation until 1844. In that year an organizational meeting was held at the home of the Alexanders on December 20 to secure funds for the first Episcopal church building in Charlotte.

The Alexanders were interested in education, and Julius served as a trustee for the University of North Carolina from 1827 to 1856. Locally he was on the committee to establish the Female Academy in Charlotte in 1827. Catherine enrolled her children in the Sabbath School in Charlotte, where Sarah taught the eldest daughters.

Julius and Catherine had six children including Daisy Alexander, born on February 20, 1837. Sarah mentions her first meeting with the infant Daisy in her journal, "She [Catherine] kissed me and then throwing back the quilt and clothing of her bed I discovered or rather saw for the first time her fourth daughter – about five days old."

In 1837 the Alexander home, which Sarah visited frequently, was located at the corner of South Tryon and 3rd Streets. Both Sarah's and Susan Nye Hutchison's journals refer to a house in the mountains

also owned by the Alexanders, "Mrs. Alexander and her family go off tomorrow for their residence among the mountains" (SNH Journal Vol4, p 139).

In addition to the law and politics, Alexander was also involved in the gold mining industry that was so prevalent in Charlotte in the 1830s and 1840s. In 1836, he was listed as one of the officials along with J. Humphrey Bissel and others in the General Mining and Manufacturing Association. In 1846, President James K. Polk appointed Alexander superintendent of the U.S. Mint in Charlotte. Julius remained at the Mint until 1851.

In 1851 Catherine and her husband moved to Lincolnton, North Carolina where they lived the rest of their lives. Catherine and Julius are buried in the St. Luke Episcopal Church cemetery in Lincolnton.

William W. Elms (1810–1871)
Mary A. Davidson Elms (1813–1866)

William W. Elms, the son of Charles Elms and Rebecca Withers, was born in 1810 in Pineville, North Carolina. As a young man William was hired as a clerk for merchant John Irwin in the village of Charlotte and eventually purchased part ownership in the store. In 1837, this establishment was known as Irwin and Elms.

In 1836, William W. Elms married Mary A. Davidson at the home of her uncle and guardian William Davidson. Mary was probably living with the Davidson family prior to her marriage and was extremely close to Sarah. It is unclear which one of William's brothers was the father of Mary.

Mary and William lived near the office of Sarah's brother-in-law Dr. D.T. Caldwell on the corner of West Trade and Church Streets.

William W. Elms became a prominent merchant in the village, and by 1850 was listed as the third wealthiest man in Charlotte. Much of Elm's fortune was lost to an investment in plank roads shortly before the arrival of the railroads.

The Private Journal of Sarah F. Davidson, 1837

Mary McComb and family

The relationship between the McComb family and the Davidsons is a little murky. Davidson family tradition states that Samuel McComb (after 1790–1848) was the half-brother of William Davidson. Sarah refers to uncle and aunt McComb and calls their children her cousins. There is definitely a blood relationship.

Samuel McComb's parents, Jane Davidson and Samuel McComb Sr., ran a hotel in the village of Charlotte. The hotel, located at the southeast corner of South Tryon and 4th Streets, was two stories high and painted white with a piazza extending the full length of the front.

Samuel McComb took over the operation of the McComb's Hotel when he came of age while his mother continued to operate the tavern that had been owned by a subsequent husband, Henry Emberson. In 1821, discovery of gold on the McComb farm three-fourths of a mile southwest of the center of the village, opened a new avenue of income for the family. Samuel McComb sold part interest of the McComb's mine to Jonathan Humphrey Bissel in 1828. It subsequently became known as The Charlotte Mine and later as St. Catherine's Mine.

Samuel McComb married Alice Brandon of Rowan County in 1809. Their children were Samuel B., Matthew, Jane (later Mrs. Green Washington Caldwell), James, Mary, William, Margaret and Elizabeth. These are the cousins referred to in Sarah's journal. Sarah was particularly close to Mary McComb.

Samuel McComb grew to a place of prominence in the area and in 1821, was elected to the North Carolina General Assembly. After this term he returned to Charlotte and served as Sheriff, Justice of the Peace and in 1835 became Commissioner of the U.S. Mint in Charlotte and supervised the construction of the mint building.

Samuel and William Davidson were business partners in several mining ventures. Sarah's reference to "pecuniary difficulty" brought on by a brother's "unjust treatment" to her father may have involved his

half-brother, Samuel McComb. Samuel secured several loans issued to William Davidson during this time period. It is also possible that Samuel McComb was the uncle that Sarah had been estranged from for several years.

Slaves of William Davidson

As listed in Deed of Trust from William Davidson to Washington Morrison, dated January 18, 1833.

- Violet & children Billy, Lonzo, Hamilton, Jones & Marshal
- Charles & wife Judy children Scott, Letty, Patsy, Catherine, Cyrus
- Ann & children Louisa, Phebia, Helling, John & another child
- Venus & children John, Lionidus, Lucius, Mary, Eliza
- Louis & wife Nancy children Biny, Fanny, Hannah, Silvey, Davida
- Cherry & children Ann, Edmond, Joe & John
- Lucy & children Antonella, Sarah, Franklin
- Amanda & children Lawson & Mary
- Wiley (miner) & wife Milly children Jane & Susey
- Matthew & wife Mary child Easter
- Creasy & her children Phebia, Roxanna
- Dedin & wife Clarey
- Joe & wife Nancy & child
- Bill & Margaret
- Jacob & Lucy and children Charles & Mary
- Others: Richard, Peter, Jim, Lawson (carriage driver), Phebia, Peter, Adam, Dick, Julia, Stephen Jim, Joe, John, Emaline, Jim, Terza, Rose, Jim, Matilda, Betsy, Adam, Molly

The Sabbath school movement

Sarah Frew Davidson devoted much time to the Sabbath School of Charlotte. According to her journal, a gentleman who afterwards became an Episcopalian minister began Charlotte's first Sabbath School: "its existence was brief—some other trials were made without effect." One of these efforts was described in the *Catawba Journal* of January 11, 1825, in which the author argued for the establishment of a Sunday school. Children who lacked the opportunity of an education and whose unsupervised and unruly behavior on Sunday affronted church going citizens would benefit from Sunday school instruction. Using the Bible and other religious texts as the main textbooks, these poor, uneducated children of the village would learn the basics of reading and writing as well as receive training in moral behavior.

The anonymous author used the same arguments as those used by the founders of the first Sunday schools in England and the United States in the late 1700s. They targeted poor children who worked in the factories six days a week and were unable to attend weekday schools. The goal of these Sunday schools was to provide a basic education and instruction in moral behavior, not religious indoctrination.

After the Second Awakening in the United States in the early 1800s, the evangelical Christians adopted the Sunday school movement. Although basic reading and writing were taught in evangelical Sunday schools, the primary goal was no longer a basic education, but salvation. The schools were taught by volunteers, the majority of whom were young women. At

first these evangelical Sunday schools were independent from the churches even though most ministers approved of them. Eventually, different denominations either began their own Sunday schools or assumed the responsibility of an existing school.

In North Carolina there were no public schools until well after the public school law was passed in 1839. It was not until the 1850s that public schools were widely available for most white children in the state. If a child's parents could not afford a tutor or private academy there were few other options. Sunday schools helped to fill that void. As common schools became more available, the churches gradually phased out basic educational skills in Sunday schools and focused on religious education for the children of members.

After experiencing an emotional religious awakening (being born again) at a revival led by the Reverend Robert H. Morrison in the early 1830s, Sarah desired to "do something in returning the love of God." She persuaded her female friends and acquaintances to revive the Sabbath school and to form the Benevolent Society. The Sabbath school (as Sarah refers to it in her journal) was first held in the Female Academy. Mr. Nathan B. Carrol, a village merchant, opened the first session with prayer. Mr. John Irwin donated books remaining from the earlier school and the teachers donated any additional supplies needed for their classes. The Benevolent Society raised money to purchase a library. The Sabbath school was formally organized with elected officers around 1833.

By the time of Sarah's journal, 1837, the Sabbath school was being held in the church where the Reverend Abner Leavenworth was minister. Classes were held Sunday morning before worship service. Evidently the students did not automatically attend the morning service, as Sarah described a Sunday when they did attend as a special occasion. The morning service was followed by a recess, and then a Sabbath school teachers' meeting in the afternoon. The teachers' meetings consisted of prayer, remarks and singing of hymns. Sarah found them helpful in many ways and intellectually stimulating. Sarah's friends involved in the Sabbath school included John J. Blackwood, John Irwin, Miss Peabody, Mrs. Alexander, Reverend Leavenworth, the Blakes and the Elms.

By 1837 the students seem to have been a mixture of poor children needing an education and children of church members. Sarah mentioned riding to the mine to recruit miners' children to attend Sabbath school. She expressed a concern that students should strive not merely for knowledge, but also for salvation. Sarah usually taught a class of children

The Private Journal of Sarah F. Davidson, 1837

although some of the teachers urged her to take over the young ladies class. In July 1837, Sarah began teaching a new class of girls. Her students included Sarah (probably her nine year old niece, Sarah Blake); her friend Catherine Alexander's daughters, Mary who was also nine years old, six-year-old Catherine; and Catherine's younger sister Mary Wilson, who was eleven years old.

The Presbyterian Sabbath School in 1837 was still providing a basic as well as a religious education. Sabbath school was directly supervised by the minister of the Presbyterian Church and the goal of the Sabbath school was salvation. It is not clear whether the children of members were also taught basic educational skills in addition to their religious education. The children of members who Sarah identified by name belonged to wealthy families who could afford tutors and private schools.

Early Holy Communion practices

Friday before the Sacrament is administered tis generally observed in this section of country as a day of fasting – prayer and attending worship in the house consecrated to Jehovah – This morning I arose with the desire and intention of observing it in the usual manner of Christians.
 Sarah Frew Davidson, Friday May 19, 1837

During the early nineteenth century, Holy Communion in the Presbyterian church was usually held twice a year. After it became customary to hold long midsummer meetings, an additional Communion service was added. According to Louise Barber Matthews in *A History of Providence Presbyterian Church*, most Presbyterian churches followed the Scottish custom of a four to five day Communion period beginning on Thursday with a "Fast Day." Sarah's journal indicates that in the Charlotte Presbyterian church fast day was Friday. Fast day was observed as strictly as if it were a Sabbath day as far as labor was concerned, which explains Sarah's guilty conscience when she unthinkingly went shopping during a fast. Sarah not only fasted on Friday she also "attended preaching in the morning — afternoon & night."

Saturday was a day of preparation with two services. Sarah attended a service in the morning and in the evening. According to Matthews, a Session would meet on Saturday to receive new members into the church and to question all members, free or slave, who desired to take Communion the next day. Tokens were distributed to members as evidence that they

had been examined by the minister or the Session and judged worthy to receive the sacrament of Communion. Tokens were sometimes small printed cards, but were usually round bits of lead or pewter about the size of today's dime that had been crudely stamped with the initials of the church or pastor.

Sarah recorded that on Sunday she and her father "again enjoyed the means of Grace," but she did not describe the services. Matthews described a typical early Communion Sunday that began with a morning "action" sermon that sometimes lasted one and one-half hours. With the whole morning service consisting of prayer, preaching and reading of the scriptures, the actual celebration of Communion sometimes did not begin until after at least two hours. Sometimes the morning service was held outside, and the sacrament was usually inside.

Before Communion began, the minister reviewed "tests" by which an individual decided if he or she was worthy to receive the Lord's Supper. The congregation was warned against participating if unprepared, impenitent or faithless. The minister then invited the communicants to come forward and sit at the tables. The tables, covered with white linens, were placed in front of the pulpit and extended into the aisles. Elders then took up tokens and served the bread and wine as the minister spoke the Communion service. The communicants came in groups until all had been served. The noon recess was next followed by the afternoon worship that sometimes lasted until after dark.

The Communion period continued on Monday with another worship service followed by Session business. Absence from Communion resulted in disciplinary action by the Session. The absentee appeared before a committee to explain why he or she missed communing. If the explanation was not satisfactory, the member was ordered to "trial." Usually the member repented, was admonished by the Session and was restored to a member in good standing. Repeated or deliberate failure to commune was a very serious offense and could result in the member's name being removed from the roll.

Gold mining and the Charlotte Mint

In 1799, about twenty-five miles east of Charlotte, a seventeen pound nugget of gold was plucked from Little Meadow Creek. Over the next several decades men across the Carolina piedmont panned their creeks and streams and dug shallow placer pits for gold that lay near the surface. The gold seekers were amateurs, ordinary farmers who worked their own land. Occasional large nuggets cropped up, but most ore appeared as particles or small lumps, or in veins of gold-laced quartz. Some was sent to the U.S. Mint in Philadelphia (prior to 1828 all domestic ore supplied to the mint came from North Carolina). Much of the gold was used locally as currency, which was in short supply. Denison Olmstead, a North Carolina geological surveyor, made the following observation: "Almost every man carries with him a goose quill or two of it, and a small pair of scales in a box like a spectacle case. The value, as in patriarchal times, is ascertained by weight... I saw a pint of whiskey paid for by weighing of 3 ½ grains of gold."

In the 1820s the Rip Van Winkle State, as North Carolina was derisively called, woke up. Samuel McComb, Sarah Davidson's uncle, discovered gold on his Mecklenburg farm in 1821. In 1825 he was the first to dig a pit mine by following a vein of gold deep into the earth. Pit mining, as opposed to surface mining, required a large investment in equipment, and a knowledge of technology. McComb was soon followed by others, and the town began to fill with experts and experienced miners from other places, primarily Europeans from England, Wales, Italy and France. The Gold

A Life in Antebellum Charlotte

Rush was on, and prosperity ensued. The flurry of activity and newfound wealth ushered in a loss of innocence.

Sophisticates came to Charlotte to seek their fortunes, among them Connecticut bachelors thirty-seven-year-old Jonathan Humphrey Bissell (1800–1845), and his twenty-five-year-old brother Edward (1812–1886). They were great favorites of Sarah. Humphrey was a lawyer and mining engineer, educated at Yale and in Europe. By the late 1820s, he was in Charlotte and in partnership with Samuel McComb. His technical expertise and scientific innovations were instrumental in Charlotte's development as a mining center. He was reputed to be mannerly, literary, broadly acquainted with science and fluent in four languages. No wonder Sarah enjoyed his company. During his years in Charlotte he was engineer for The Charlotte Mine (later named St. Catherine's Mine), becoming part owner in 1828. In 1836, in association with William Julius Alexander, he chartered the General Mining and Manufacturing Association. He never married, and died of pneumonia in Philadelphia in 1845.

Edward Bissell also owned interests in gold mines. He was mentioned more frequently by Sarah, and seemed to possess scientific acumen similar to his brother. Neither brother was religious, at least in Sarah's eyes. She wrote with a sense of shock and repugnance that Edward proclaimed that much in the Bible had been disproved by science. Edward married in the 1840s, and became the father of twelve children. He died in Mecklenburg County in 1886.

The dangerous work below ground attracted another element of society, adventurous hard scrabbling men who often spent their free time drinking, gambling and engaging in rowdy behavior. The children of these somewhat impoverished men were recruited for Sarah's Sabbath school. Many slaves were hired out to the mines, and a few employed women. Humphrey Bissell and his partner hired fifty-nine slaves in 1830. Charlotte was no longer a sleepy village.

By the mid 1830s Mecklenburg County had become the state's chief gold producer. Charlotte and its surrounds were riddled with mine shafts. Sarah's father, William Davidson, had one on his property which she mentioned in her journal. Commerce which follows money settled in. Sarah's shopping trips reflect the new prosperity; in fact the depression of 1837 that severely crippled the nation's economy had little effect in the gold fields.

Early in the decade it became apparent that a local branch of the U.S. Mint would be a great advantage. As William Davidson said, "to turn

The Private Journal of Sarah F. Davidson, 1837

our gold into money, and the money into the pockets of the people." Samuel McComb and Humphrey Bissell were active advocates, and in 1835 Charlotte was awarded a branch with McComb as commissioner. Noted architect William Strickland was hired to design the building. Construction began, and in January of 1837 John Wheeler was hired as superintendent. The mint began its operations in December of that year, and the first gold coin was struck in March of 1838.

John Hill Wheeler was born in 1806 in Murfreesboro, a small village in the northeastern corner of North Carolina. He was educated in Washington, D.C. and at the University of North Carolina, and he was admitted to the North Carolina bar in 1827. Before coming to Charlotte he had served in the state House of Commons representing his native county and had held at least one political appointment in Washington. In 1837 he was appointed superintendent and treasurer of the Charlotte branch of the Mint; he was newly widowed and the father of several small children. By midsummer, when Sarah first mentioned him, mint construction was well under way. Wheeler had taken occupancy of its living quarters, and had become an important man in the community. Sarah always refers to him as Col. Wheeler, probably reflecting his rank in a local militia.

In 1838 Wheeler married Ellen Sully, daughter of Thomas Sully, a renowned Philadelphia artist. Wheeler remained at the mint until 1841. He then moved to his Lincoln County plantation, served as state treasurer, wrote a history of North Carolina and later held a number of federal diplomatic and bureaucratic positions. During the Civil War he lived in Lincoln County, otherwise he moved back and forth between his native state and Washington, where he died in 1882.

During the course of Sarah's journal the mint was in its final stages of construction and was quite the social gathering place. Wheeler and his employees were popular figures about town. When the mint opened in December of 1837 regulations were published with regard to visitors. The mint welcomed visitors daily, except in wet weather, and all visits were conducted by an attendant. They were requested not to handle coins, precious metals, apparatus or machinery without permission, and asked to sign a guest register. Tipping employees was prohibited.

The main floor of the building contained offices, assaying and melting rooms, as well as a piazza and Wheeler's living quarters. The basement consisted of boilers, a blacksmith's shop, melting and crucible rooms, a refinery and storage for acids.

A Life in Antebellum Charlotte

The Charlotte Mint continued to coin money until the Civil War. The Confederate treasury was stored there for a while, and the building was seized briefly by the state of North Carolina. After the war it once again became federal property and was used for several years as a military post. Then it reopened as an assay office, but never again minted coins.

North Carolina's mines had become unprofitable. They were fairly well played out, but a larger problem was a high water table. Pumping procedures were expensive, and fraught with potential mishap. North Carolina was no match for the rich lodes of California.

In the 1930s local preservationists raised funds to have the Mint building moved to a suburban location to be used as an art museum where it remains, much augmented, to this day.

A short history of Rosedale

Three miles from the heart of Charlotte, nestled among ancient trees and enchanting gardens on the banks of Little Sugar Creek, you will find Historic Rosedale Plantation. The imposing Federal house, built in 1815 by local merchant and tax collector Archibald Frew, is one of Charlotte's few remaining antebellum homes.

After the American Revolution, with a new republic emerging, the American people rejected the old English ideals and embraced a new classical style in architecture, a style emulating the Greek and Romans, as illustrated by discoveries at Herculaneum and Pompeii. Mr. Frew chose this classical style for his new home. Local granite, heart pine and brick hand-formed from the Carolina red clay soil were used in the construction of this beautiful tripartite structure. The house made such an impressive sight, located within view of the great wagon road leading into the village, that neighbors along Sugar Creek named it "Frew's Folly."

The year 1816 brought terrible drought conditions that made it impossible for many citizens of the county to pay their taxes. Archibald Frew, as tax collector for Mecklenburg County, was responsible for the amount of the taxes owed by the county and was sued by the federal treasury. As payment, his house and plantation were seized and sold at public auction. Agents for William Davidson, Mecklenburg County representative to the United States Congress and Archibald Frew's brother-in-law, quietly purchased the property at the auction. All money from the sale was sent to Washington to pay the taxes of the county.

A Life in Antebellum Charlotte

Archibald Frew lived at the plantation and acted as overseer for his brother-in-law until his death on April 15, 1823.

Senator William Davidson sold the plantation in 1833 to his new son-in-law, Dr. David T. Caldwell. This prominent Mecklenburg physician practiced medicine from his office in the village of Charlotte, served as elder in Sugar Creek Presbyterian Church and is buried in Settler's Cemetery. The plantation was occupied and operated by Dr. Caldwell and his family from 1826 until his death in 1862.

Approximately twenty enslaved Africans worked the 911-acre subsistence plantation that included the manor house, slave quarters, a cotton press, grist and sawmills and other necessary buildings during the early 1800s. It was during the height of the plantation period that Sarah Frew Davidson visited her sister often at what was then known as the Caldwell Plantation.

Descendants of the original owners occupied the home until 1986, at which time a private organization was formed, with help from the local Colonial Dames, to purchase the house and begin restoration. A six-year restoration project culminated with the opening of the house to the public in 1993.

Rosedale is noted for its remaining faux-grained woodwork, original French wallpaper and extensive family records that give the public a unique glimpse into the plantation life of this bustling little village before the Civil War. Gardens from the early twentieth century dominate the remaining 8½ acres of property—all that is left of the original 911-acre antebellum plantation.

Today the site provides guided tours to many school children, tourists and local individuals, and conducts many special events throughout the year. Historic Rosedale is open to the public for drop-in tours Thursday through Sunday afternoons 1:00 to 4:00, or for scheduled group tours at other times. For more information, please contact Historic Rosedale Plantation.

Historic Rosedale Plantation
3427 North Tryon Street
Charlotte, North Carolina 28206
704.335.0325
www.historicrosedale.org

Selected bibliography

Books

Alexander, J.B. *The History of Mecklenburg County From 1740 to 1900.* Charlotte: Clearfield, 1902.

Farnham, Christie Anne. *The Education of the Southern Belle: Higher Education and Student Socialization in the Antebellum South.* New York: New York University Press, 1995.

Ferguson, Herman W. *Mecklenburg County, North Carolina—Minutes of the Court of Common Pleas and Quarter Sessions—Vol IV: 1831—1840.* Charlotte: privately printed, n.d.

Kierner, Cynthia A. *Beyond the Household: Women's Place in the Early South, 1700-1835.* Ithaca, New York: Cornell University Press, 1998.

Knapp, Richard F., and Brent D. Glass. *Gold Mining in North Carolina, A Bicentennial History.* Raleigh: Division of Archives and History, North Carolina Department of Cultural Resources, 1999.

Matthews, Louise Barber. *History of the Providence Presbyterian Church, 1767-1967.* Matthews, North Carolina: Brooks Litho, 1967.

Rankin, Richard. *Ambivalent Churchmen and Evangelical Churchwomen: The Religion of the Episcopal Elite in North Carolina, 1800-1860.* Columbia: University of South Carolina Press, 1993.

Sherrill, William L. *Annals of Lincoln County, North Carolina: Containing Interesting and Authentic Facts of Lincoln County History Through the Years 1749 to 1937.* Charlotte, 1937.

Springs, Katherine Wooten. *Squires of Springfield.* Charlotte: William Loftin, 1965.

Thompkins, D.A. *History of Mecklenburg County (North Carolina) and the City of Charlotte, from 1740 to 1903.* Charlotte: Charlotte Observer Printing, 1903.

Wilkinson, Henrietta H. *The Mint Museum of Art at Charlotte, A Brief History.* Charlotte: Heritage Printers, 1973.

Unpublished Manuscripts

"Journal of David T. Caldwell." (Davidson–Caldwell Collection housed at the University of North Carolina Charlotte.)

"Susan Nye Hutchison Journal, 1790–1867." (Southern Collection housed at the University of North Carolina Chapel Hill.)

Newspapers

Carolina Watchman. Salisbury, North Carolina, 1832–1898.

Charlotte Journal. Charlotte, North Carolina, 1835–1851.

Raleigh Register. Raleigh, North Carolina, 1823–1868.

Index

A

Alexander, Anabella 84, 119
Alexander, Catherine Wilson (daughter of Catherine) 109
Alexander, Elvira Catherine Wilson (Catherine) 51, 52, 53, 57, 82, 83, 84, 89, 90, 96, 100, 101, 102, 103, 107, 108, 110, 112, 113, 114
Alexander, Elvira Davis McCoy 111
Alexander, Jane Henderson 96, 97
Alexander, Mary Wood 109
Alexander, Sarah 65, 89
Alexander, William Julius 52, 112, 113, 114
Amanda 42, 58, 59, 60, 61
aurora borealis 108

B

Bakewell's Geology 47, 48
Benevolent society 45, 46
Bissel, Edward Hamilton 42, 100, 101, 103, 107, 112, 121
Bissel, Humphrey 82
Blackwood, John J. (Ivor) 33, 43, 46, 53, 70, 74, 83, 85, 89, 92, 94, 95, 96, 98, 100, 104, 111, 113, 114, 120, 122
Blake, James H. 40, 46, 49, 53, 63, 84, 94, 100, 102, 103, 104
Blake, Margaret Davidson 50, 52, 53, 59, 60, 65, 70, 71, 81, 84, 93, 94, 95, 98, 101, 104, 107, 110, 111, 114, 119, 121
Blake, Margaret M. 82
Blake, Sarah Elizabeth 47, 49, 64, 65, 109
Blundell, Caroline 112
Boyd, Joshua D. 103

C

Caldwell, Dr. David Thomas 112
Caldwell, Dr. Green W. 81
Caldwell, Dr. Pinckney Coatsworth 59, 95, 98, 100, 101, 102, 114
Caldwell, Harriet Elizabeth Davidson 43, 66, 91, 92, 102, 109, 112
Caldwell, Jane McComb 93, 101
Caldwell, Sarah Jane 103
Caldwell, Sarah Roxanna Wilson 101, 114
Carrol, Nathan B. 45
Charlotte, North Carolina 33, 44, 46, 51, 101, 102
church 43, 45, 46, 50, 51, 53, 78, 82, 83, 84, 90, 91, 93, 98
churches
 Baptist 41, 83, 84, 90
 Methodist 41, 83
 Presbyterian 41, 83
Communion 45

D

Davidson, William 42, 43, 47, 49, 52, 59, 61, 63, 64, 65, 70, 71, 72, 79, 82, 84, 97, 111, 121
Davidson, William Frew 52, 63, 72, 73, 78, 82, 89, 92, 93, 95, 97, 99, 100, 103, 104, 111, 121
death 60, 61, 63, 98, 113, 120
domestic duties 104, 109
 gardening 41, 42, 43, 64, 66
 sewing 43, 107, 119

Dunlap, Dr. David Richardson 103
Dunlap, Mary Jack Lowrie 100, 104
Dyott, Miss 65, 90, 96, 100, 101, 108, 111, 114
Dyott, Mrs. 100, 114

E

Elms, Mary A. Davidson 41, 49, 51, 52, 61, 64, 65, 70, 71, 91, 93, 94, 95, 100, 103, 104, 107, 110, 113, 121, 122
Elms, William W. 41, 52, 63, 64, 70, 71, 83, 113, 114

G

Grove, The 39, 40, 46, 47, 65, 73, 77, 84, 92, 93, 111, 119, 121

H

Harris, Dr. Thomas J. 59, 78, 79, 94, 95, 111, 113
Harris, Elizabeth Locke 93, 111, 113
Hutchison, Susan Nye 46, 49, 65

I

Irwin, Francis 123
Irwin, John 45, 49, 62, 63, 97, 104, 107
Irwin, Mary Ann 65, 78, 82, 84, 94, 115
Irwin and Elms Store 49

L

Lawson 63, 79, 95, 98, 109, 110
Leavenworth, Fredrick P. 74
Leavenworth, Mrs. 112, 121
Leavenworth, Rev. Abner Johnson 41, 46, 50, 58, 60, 70, 74, 78, 83, 90, 91, 92, 94, 96, 101, 109, 112, 114, 120, 121
Lincolnton, North Carolina 74, 77, 100, 104
Locke, John 39
Longstaff, Dr. George Dixon 112
Lowrie, Margaret Alexander 84, 94, 112
Lucy 62, 63

M

McComb, Alice Brandon 95, 98, 120
McComb, Elizabeth 57, 103
McComb, Mary 59, 60, 69, 78, 81, 84, 89, 92, 94, 95, 97, 100, 111, 114, 123
McComb, Matthew 78, 123
McComb, Samuel 69, 101, 111, 112, 121
McDowell, Robert Irwin 91, 112
mining 47, 50
Morrison, Mary Graham 83
Morrison, Rev. Robert Hall 45

O

Osborn, James Walker 90, 92, 113

P

Patrick, James 41, 49, 50, 52
Peabody, Elizabeth Manning 121
Peabody, Mary Ann 41, 74, 96, 101, 120
Perry, Andrew J. 62
pianno 92, 95, 102, 108, 114

R

Ramsour, Adeline 51, 74, 99, 104
Ramsour, Harriet 51, 74

S

Sabbath school 41, 44, 45, 46, 53, 65, 69, 70, 71, 78, 83, 93, 96, 97, 98, 109, 115
servants 41, 43, 61, 63, 70, 73, 78, 93, 98, 99, 103, 108, 111
Smith, Franklin L. 113
Smith, Mrs. 114, 120
Springs, Laura 57
Springs, Mary Amanda Moore 53, 65, 95
Strange, William F. 95, 111

U

U.S. Mint (Charlotte) 95, 107, 114

W

Wallace, Dr. Rufus A. 85
Wheeler, Col. John Hill 90, 94, 95, 112, 114, 115, 123

Williams, Henry B. 98
Williamson, John 78
Williamson, Sarah A. 49, 51, 74, 100
Wilson, Margaret 84, 103
Wilson, Mary G. 65, 109

About the editors

Karen McConnell, Janet Dyer and Ann Williams have been immersed in the history of the Charlotte, North Carolina, area for many years. They are members of the Mecklenburg Historical Association and serve on that organization's Docent Committee. Their activities range from scholarly research using primary documents and a broad array of historical collections at academic archives throughout the state, to working with children in historical learning activities such as dipping candles or creating cornhusk dolls. All three volunteer at a half dozen historic sites, some on a regular basis, and others for special events. They all give tours at Historic Rosedale, and upon occasion assume the clothing and persona of our foremothers, to bring history to life. In addition to Mecklenburg County families, they have researched everyday life in the antebellum piedmont, with an emphasis on the experiences of enslaved African Americans.

Karen McConnell is curator of education at Historic Rosedale. In that capacity she develops and directs public and educational programming, handles public relations and trains and supervises volunteers. She has researched and written dramatic skits and other

interpretative material for Rosedale and other sites. Karen is particularly knowledgeable about the families who long ago occupied Charlotte, and their complex interrelationships. She is a native of Salisbury, North Carolina, and lives there in family farmhouse built over 150 years ago. She and her husband Stan have restored the home and surrounded it with gardens of Karen's creation. She and Stan enjoy dancing to beach music, and have won a number of competitions.

Janet Dyer is an accomplished researcher, especially in archives of nineteenth-century newspapers and court records. She has extensively studied the Catawba River, its fords, ferries and fisheries, and its influence on nineteenth-century life. Janet developed a passport program involving about a dozen historic sites that encourages young people to visit and expand their appreciation of these sites and our regional heritage. She is a member of the Cooking Guild of the Catawba Valley, which demonstrates and researches open-hearth cooking. She enjoys dancing, camping and bicycling. She and her husband Rob operate a bed and breakfast inn on the banks of the Catawba River.

Ann Williams is the author of *Your Affectionate Daughter, Isabella*, a book that tells the story of the Torrance family in antebellum Mecklenburg County. It is based on an extensive collection of family papers and letters in the manuscript collection of the University of North Carolina at Charlotte. Ann has a special interest in historic fabrics, clothing and needlework. She has written several articles for textile publications and has replicated hand-woven coverlets and many period garments. She and her husband Jim are Revolutionary War era reenactors, and have presented living history at many sites across the countryside.